Print it!

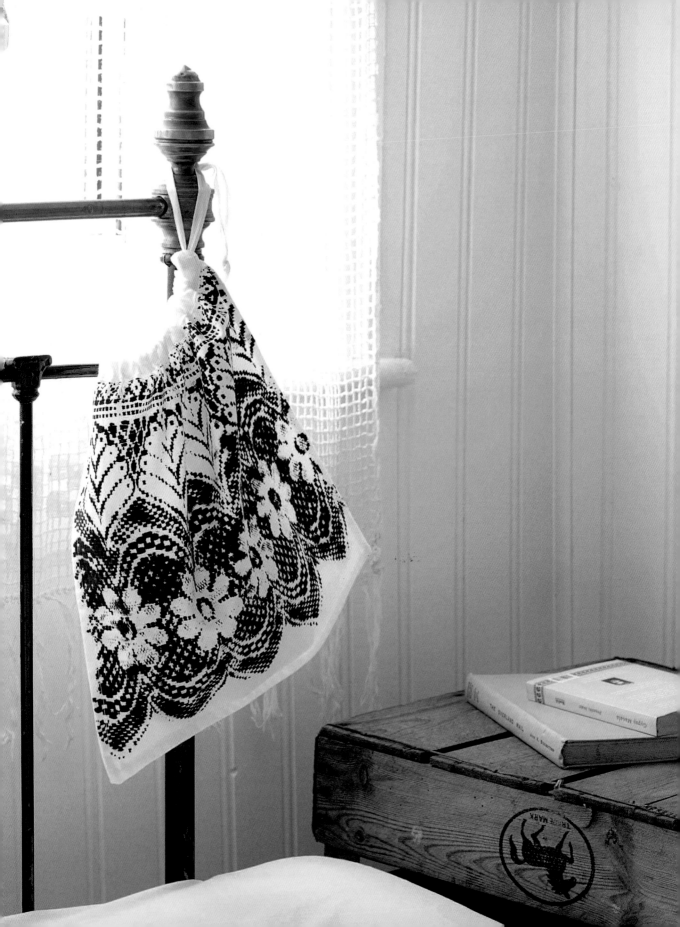

25 projects using
hand-printing techniques
for fabric, paper
and upcycling

Joy Jolliffe

Print it!

COLLINS & BROWN

Published in the United Kingdom in 2016
by Collins & Brown
1 Gower Street
London WC1E 6HD

An imprint of Pavilion Books Company Ltd

Distributed in the United States and
Canada by Sterling Publishing Co., Inc.
1166 Avenue of the Americas,
New York, NY 10036

Photography by Holly Jolliffe

ISBN 978-1-91090-488-6

A CIP catalogue for this book is available
from the British Library.

10 9 8 7 6 5 4 3 2 1

Reproduction by Rival Colour Ltd, UK
Printed and bound by 1010 Printing
International Ltd, China

This book can be ordered direct from the
publisher at www.pavilionbooks.com

contents

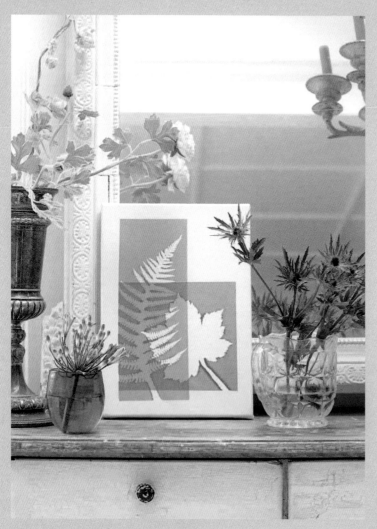
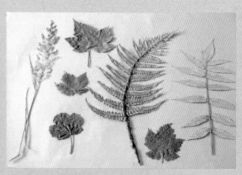

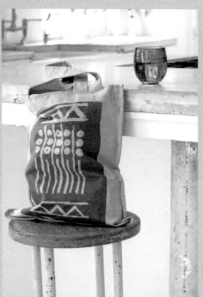

introduction

It was while studying fashion design at art college many years ago that I was introduced to, and completely seduced by, screenprinting. I still feel the same excitement even now whenever I lift the screen from the fabric and see an image printed there. This was the start of an enduring fascination as I began experimenting with the infinite ways to add surface decoration to fabric.

I was taught basic sewing skills at school and began making my own clothes as a young teenager. Feeling totally in tune with the *Zeitgeist* of the 1970s, I joined long queues for Saturday afternoon jumble sales to spend mere pennies on gorgeous vintage clothes. It was there that my love affair with textiles truly began, and I vamped into my college lectures wearing crêpe de Chine nightwear and ankle-length coats made from patterned chenille curtains. Since that time, the interest in upcycling has grown enormously and many of these projects fit into this category: the Sundress Makeover, the Daisy Border Tea Towel, the Blue-Sky Cloud Pillowcase and many more. These projects are more than 'just' craft, they breathe new life into old things and by reusing we help our pockets and our planet.

During the years in between, I worked for some time at the local high school. Within the art department and the needlework classes we developed 'creative textiles' projects for the new curriculum, and a lot of the ideas for this book had their beginnings in these projects. Working with mixed-ability and also some reluctant students, my aim was for everyone to taste success. The projects here are designed to encourage the less experienced and challenge the able. As you are already reading this book, I'm taking your enthusiasm for granted!

As art students we were always encouraged to keep sketch- (or 'inspiration') books. Literally anything that we found interesting was stuck into those books: magazine cuttings, scraps of fabric, a pressed flower or a bus ticket. These valuable little books became the source of many future design ideas. I would encourage you to keep an ideas book like this, too. I still do. It keeps you focused as a creative person and helps you to remember all the ideas that come to you throughout the day.

With the techniques mastered and your confidence sky high, I hope you'll spend a lot of time experimenting! You can buy ready-mixed printing inks, although the real joy comes when you start to mix your own colours. See what works and what doesn't. Find your own favourite colours and combinations. See what happens when you decorate coloured or patterned backgrounds. How do colours mix when they overlap? Textured fabric can fragment your printed image, but equally it can add interest. Try things out and just keep learning.

Finally, don't give up if a project isn't successful first time. Practice makes perfect, and experience really does improve technique. I truly hope that this book enables you to enjoy discovering your own creative potential.

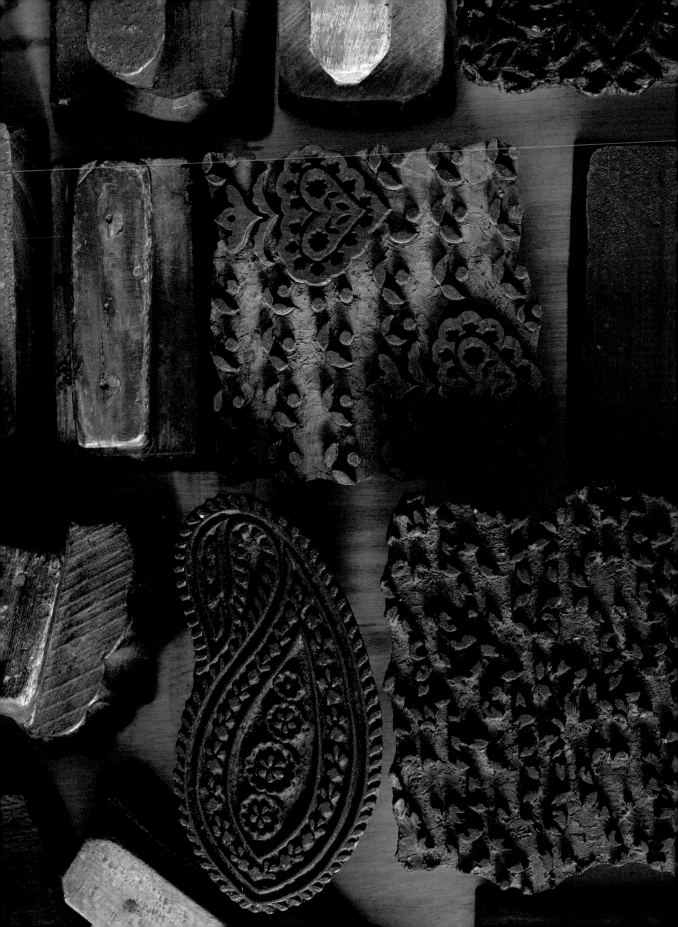

a short history of printing

Textile decoration is an ancient art. Some of the earliest samples came from China and Egypt AD *c*.220, while Egyptian printed cloth dates from the 4th century.

The first known example of block printing is a Buddhist scripture from AD 868. As early as the 5th century India was exporting block prints to the Mediterranean region, and by the 13th century this process had reached Europe, where it was used solely for textile printing. In the Americas, it evolved alongside traditional native American textile printing.

Commercial textile printing began in England in 1676, with the establishment of a business near Richmond-upon-Thames. Thomas Bell invented the first cylinder printing machines for textiles in 1783, and the textile industry as a whole developed massively as part of the industrial revolution.

block and screenprinting

Textile printing has evolved from block printing by hand through various techniques: copperplate, roller, perrotine, screenprinting by hand, by flat bed and rotary machines, and now digital printing. The two areas with most relevance to the projects in this book are block printing and screenprinting – both of which have long histories.

block printing

The very earliest 'stamping' must be the handprints or stencils that have been discovered in caves. Simple stamps have been found, too. There is also evidence of block printing being used on garments and wall hangings in medieval monasteries. The most ingenious example I've discovered in my research comes from the 4th century: smoke from burning linseed was used to blacken a printing block, and the sooty surface was then stamped onto damp cloth.

In England, weaving has a long history – block printing, however, was an imported craft. In the 16th century, traders introduced richly patterned textiles from the East. These fabrics were lightweight, pretty and very popular. In 1700, Parliament actually prohibited their import for a period, as weavers in England were losing trade. Print and dye works were unstoppable, however, and a new industry developed employing hundreds of workers.

Printing history would not be complete without mentioning William Morris. As the industry developed during the 18th and 19th centuries, there was a feeling that the quality of materials and designs had been sacrificed for quantity. Morris wanted to revive block printing and to return to the individual skills of the artist/craftsman in the production of textiles. In 1873, he and his fellow artists began printing designs from their own printing blocks. The beautiful results of some of this work can be viewed at the Victoria and Albert Museum in London.

The production of woodblocks deserves a little history of its own. The skills of the block-maker and the printer were totally interdependent. Historically, after the design was produced it was laid in reverse onto a large, smooth wooden block and fixed into place. Craftsmen of various skill levels carved the original image into the wood. The blocks were made in different woods for different purposes and the design stood out in relief on the carved wood. Separate blocks had to be carved for each colour. The cloth was then stretched onto a long padded table. The block face was pressed against a dye-saturated woollen surface and then applied to the cloth, and a blow with a wooden mallet to the back of the block transferred the design. 'Pitch pins' were nailed into the corner of the block, which helped the printer to line up the successive impressions.

screenprinting

Screenprinting is one of the earliest methods of printing. It involves the passing of ink through a mesh or screen that has been stretched on a frame to which a stencil has been applied. The technique was first used by the Chinese 2,000 years ago – human hair was stretched across a wooden frame to form the screen, to which was attached a stencil of leaves. In this way, possibly the first screenprinted image was produced.

The Japanese adapted the process, using woven silk for the mesh and lacquers to make stencils. Europe had to wait until the 1700s, when silk for the mesh became more easily available through trading, and a profitable outlet for the medium was gradually developed. It was first patented in England in 1907 and used to print wallpaper, linen and silk fabrics.

During the 20th century, screenprinting became fully mechanized and widely used on fabric and wallpaper, becoming a cheaper alternative to printing with wooden blocks. Experiments with photo-reactive chemicals also revolutionized the industry, making photo-imaged stencils available for commercial screenprinting.

From using hair, then silk and now polymer meshes, screenprinting has come a long way. Although technology has developed the craft for industry, the basic technique remains the same. Screenprinting has been adopted by many artists for its creative and expressive possibilities – notably Andy Warhol, who popularized the craft with his repeat images in the early 1960s. It is widely used today for mass production of images on everything from posters to t-shirts, but is equally well suited to the production of complex original one-off designs.

materials & equipment

Within each project in the book you will find a list of items that are needed to complete your designs, some of which are detailed below. It isn't necessary to buy everything at once – you may decide to beg, borrow or buy what you need for one project at a time. As you progress through the book you will find that many of these items are used repeatedly, but only have to be bought once.

water-based printing inks

These are the ideal type to use for printing. They are easily removed from the screen using water and a little soap. Solvents aren't generally required for cleaning – which is better for the environment as a whole, and for your own workspace.

image transfer paper

A great medium for fast image making. Available from art and craft shops and office suppliers, image transfer paper enables you to transfer your chosen image onto most types of fabric. They are now produced by several different manufacturers and they come with very clear instructions for use. Requires a desktop printer.

fabric transfer crayons

Very low-tech method for 'printing' onto fabric. These crayons are widely available and usually come in packs of eight different-coloured crayons. Designs drawn onto paper with these crayons are then transferred to fabric using heat. A really child-friendly tool, but a creative adult can also produce great prints using this method.

image transfer paste

Another low-tech product. Available from art and craft shops, a 50ml (1¾ fl oz) tube of transfer paste costs very little and is enough for two A4 applications. It's a good idea to practise first to get used to the medium and to judge the right amount of paste to use on your photocopied image.

image scanner

This piece of equipment allows you to convert a printed image into a digital format. This can then be downloaded to your computer for further manipulation and printing. A4-size desktop scanners are the most commonly available.

scissors

I keep one pair of scissors for fabric and another for paper. Cutting paper/card blunts the scissor blades; when used on fabric they snag and don't cut cleanly. I tie a scrap of fabric onto one handle of my fabric scissors to ensure I remember which is which.

cutting mat or board and craft knife

These pieces of equipment make all paper/card/stencil and potato cutting more efficient and successful. For the projects in this book, I have recommended that you use a cutting board for potato cutting and a cutting mat for cutting your card or paper. 'Self-heal' mats are available from art and craft shops, and come in various sizes (mine measures 30 x 45cm/11¾ x 18in). They are marked with a grid which helps you to cut accurate, straight lines and right angles. The cut marks magically disappear so that the cutting surface remains smooth. Craft knives are sharp and cheap, and available from art and craft shops. They ensure that your cut lines are clean. They come with a little plastic sheath to cover the blade when the knife is not in use.

cutting potato shapes

Using a cutting board and a craft knife, cut your potato in half and dab the cut surfaces onto kitchen paper to absorb some of the moisture. Carefully make small cuts around your design shape to a depth of approximately 1cm (½in), so that your shape is in relief. When considering design-shape choices, remember that simple, solid shapes work best. If you cut sections into your potato that are too narrow, they might snap off in use.

your printing space

A dedicated space for printing is desirable but not always possible. However, you do need a flat and lightly padded surface for printing, running water close to hand, and some elbow room. The kitchen table is fine, although it's a good idea to protect the surfaces of your working area as some inks can stain. For the same reason, it's worthwhile wearing old or protective clothing while printing. The printing surface I use consists of a flat board with a layer of thin foam stapled onto it, and on top of that is plastic and absorbent cloth. For small-scale work – when using stamps, for example – a wad of newspaper can be substituted for the foam and the plastic.

other helpful hints

▬ Do a trial on paper or waste fabric before printing the actual piece.

▬ Don't print over hems or seams – the uneven surface will distort the image.

▬ Keep spare and leftover inks in screw-top jars.

▬ If you make a mistake, stop and think: sometimes it's better to leave it, as overprinting can make the mistake more obvious. (Hand techniques aren't meant to produce machine-like accuracy; small deviations can give a design character and animation.)

▬ If you use a hairdryer to speed up the drying process, make sure the garment or fabric is taped down securely.

▬ Keep your hands clean during the printing process. It isn't meant to be messy!

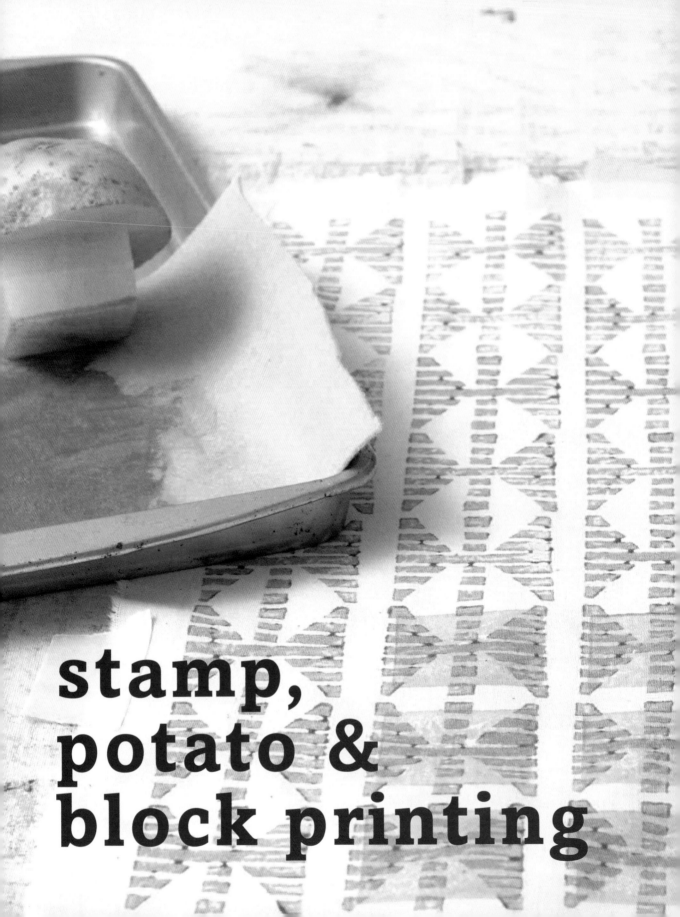

stamp, potato & block printing

The projects featured here use shop-bought stamps, old wooden blocks and even cut potatoes. The work that you produce can be as simple or as complex as you want to make it, and – once you get hooked – you will realize that a vast array of different objects can be used for this method of printing. Try corks, wood grains, pastry cutters, leaves and screwed-up newspaper for a range of exciting effects.

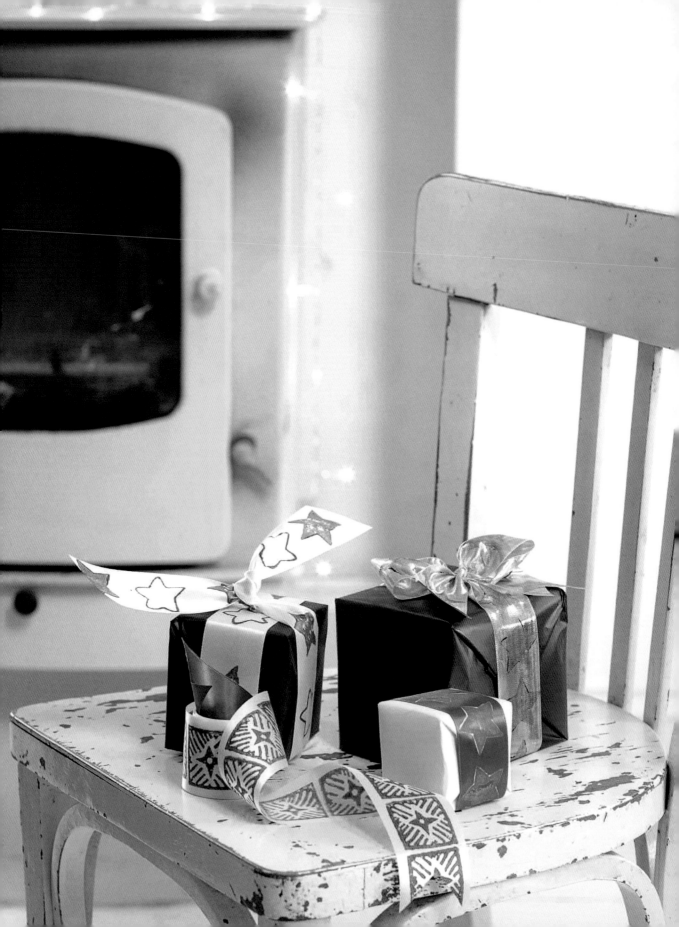

upcycle project

five christmas stars gift ribbons

Whoever receives a gift tied with these striking ribbons will know they are special. They are actually very simple to make – I found all of these ribbons in a local shop that sells cake decorations, and used a potato, pastry cutter and wooden stamp to print the design. Other Christmas images that can be cut from a potato include holly leaves, Christmas trees and angels.

potato, pastry cutter and
commercial stamp

MATERIALS

Potato
Kitchen paper
Craft knife
Cutting board
Marker pen (optional)
White, grey and red printing inks
Mixing bowls
Tablespoon
Metal or plastic trays
Felt
Five ribbons
Masking tape
Shop-bought stamp
Star-shaped pastry cutter
Soft brush

1

Choose a potato that is large enough for you to hold comfortably. Wash it, dry it and cut it in half. Then dab the cut surfaces onto kitchen paper to absorb some of the moisture. Using a craft knife on a cutting board, cut a star shape into your potato (see p.14). You can draw your design onto the potato with a marker pen before cutting if you wish.

2

Mix the printing inks to the colours that you require. Spoon three tablespoons of the first colour onto a tray. Spread the ink into a thick layer, leaving a gap around the edges.

3

Cut a piece of felt slightly larger than the ink pool. Lay it on top of the ink. The slight over-sizing helps prevent ink from squirting out around the edges. Using your potato stamp, press it repeatedly onto the felt until the ink is forced through to the surface. Prepare the second and third ink, felt and tray in the same way.

The wide ribbons used for decorating cakes are especially good for potato prints, as the shapes produced on a cut potato are quite chunky.

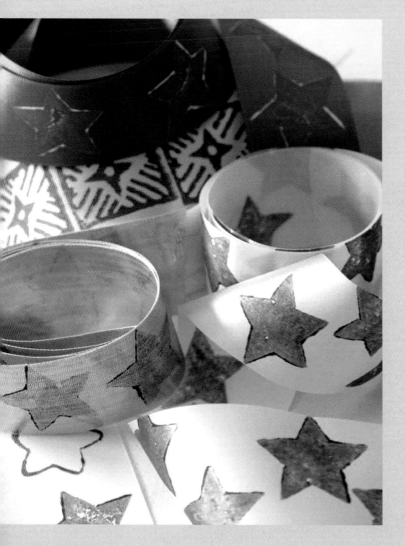

4

Lay a ribbon out flat onto the printing surface and fix each end in place with masking tape. To print the ribbon, press the potato stamp onto the inky felt and then onto the ribbon.

5

Here, three of the ribbons are printed with the same potato stamp. If the potato does start to break up, cut another one.

6

On the fourth ribbon the method is the same but I've used a wooden, shop-bought stamp. The fifth ribbon has been printed with a potato stamp and a star-shaped pastry cutter. The possibilities of colour and pattern are endless, and it's good to experiment. Recharge your stamp with ink every time you print.

7

The ink on the ribbons doesn't need fixing unless they are to be washed. Clean your stamps with a soft brush and soapy water.

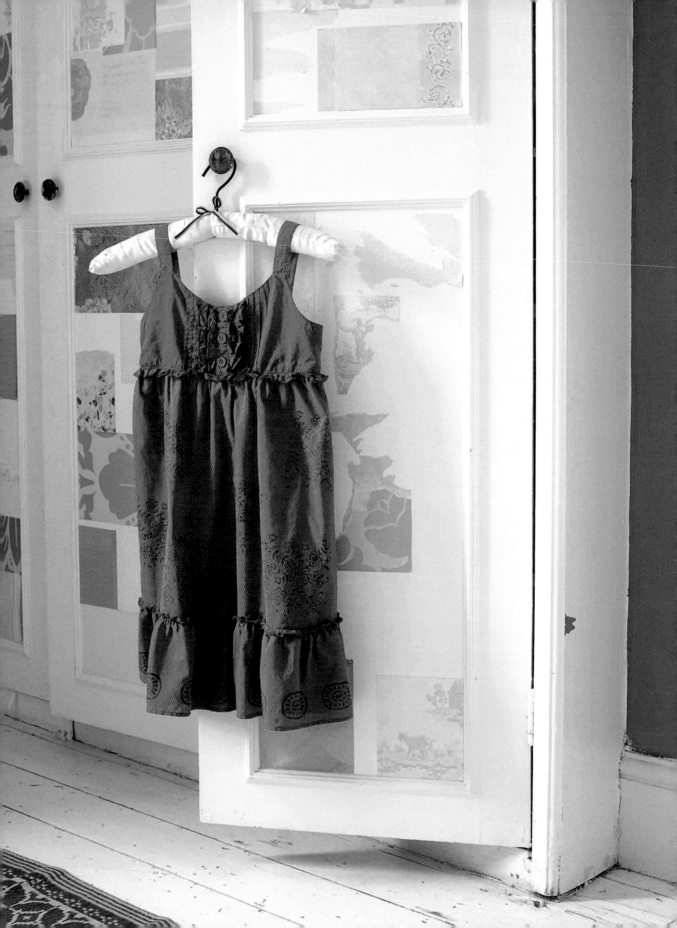

upcycle project

pretty
in pink
sundress
makeover

Enliven an item from your wardrobe with your own unique design – here, using block printing. Decorative wooden stamps and blocks are now widely available – most art shops and gallery shops stock them. I have a small collection myself. Some people buy them simply to display as ornaments. Of course, they're made for printing and are so easy to use it's a shame not to use them!

commercial printing blocks
on a garment from your
wardrobe

MATERIALS

Purple printing ink
Mixing bowl
Tablespoon
Metal or plastic tray
Felt
Variety of wooden printing blocks
Spare piece of fabric for trials
Garment
Ironing board
Soft brush

A hand-me-down from big
sister can be turned into
a 'new' dress by adding this
simple decoration.

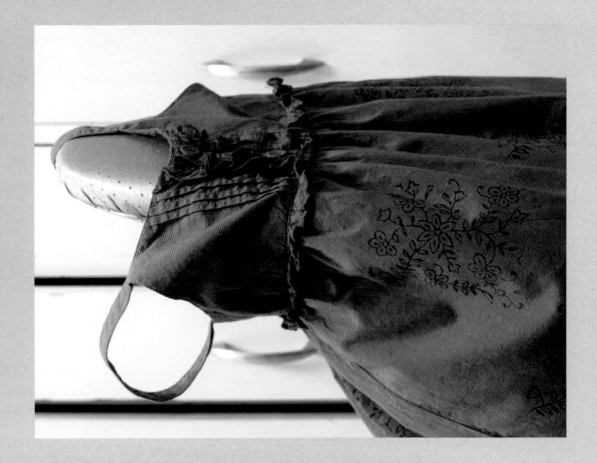

1

Mix the printing ink to the required colour. Spoon three tablespoons of ink onto your tray. Spread the ink over the base in a thick layer, leaving a gap around the edges. Make sure that the area of ink matches the size of your printing block.

2

Cut a piece of felt slightly larger than the ink pool. Lay it on top of the ink. The slight over-sizing helps prevent ink from squirting out around the edges.

3

Choose your block. When printing on an existing garment, consider the scale of the block you use relative to the size of the garment. I used a large block on the main part of the dress, while a smaller block worked well as a border along the flounce.

4

Do a trial first on some spare fabric before working directly on your garment. Remember, the colour you print can be affected by the colour of the fabric that you print on.

5

Lay your garment onto the printing surface. For this project, I used an ironing board as my printing surface, so that I could move the garment round as I printed.

6

Using your first block, repeatedly stamp onto the felt until the ink is forced through to the surface. Press the inky block firmly onto the garment.

7

Allow the ink to dry before fixing (see p.140).

8

Wash the blocks using a soft brush and soapy water.

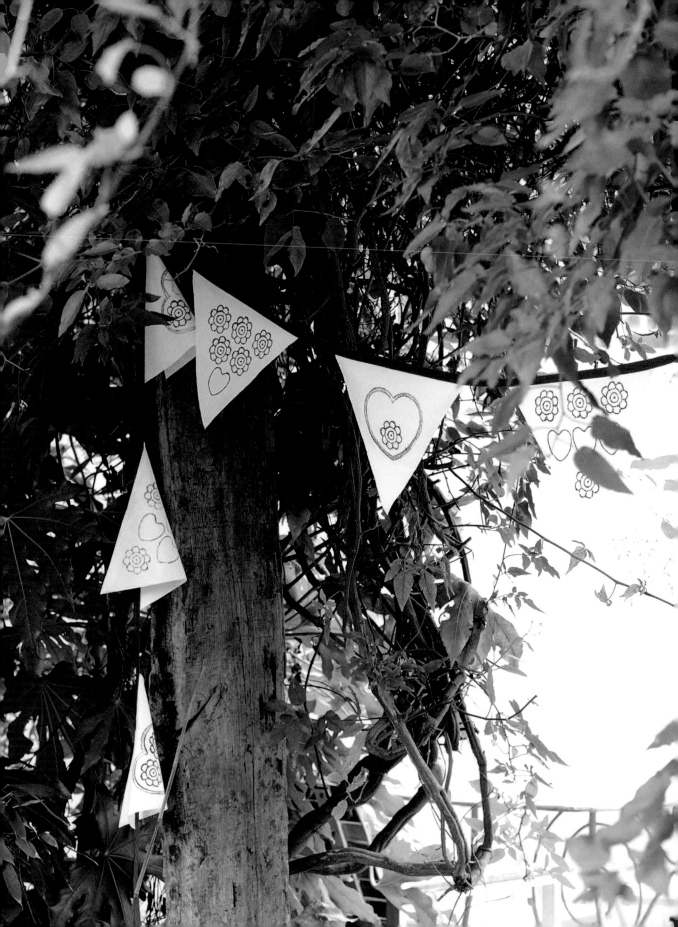

hearts and flowers birthday bunting

Put up this beautiful bunting to celebrate a special day. My colour scheme and stamp designs are chosen to celebrate a girl's birthday – you may wish to choose your own theme. This bunting doesn't have to be sewn; staple your fabric or paper flags to seam binding or cotton tape if you prefer.

two pastry cutters and a flower stamp

MATERIALS

Card
White cotton fabric (or paper) – for nine
 triangles 20 x 20 x 20cm (7¾ x 7¾ x 7¾in)
Tailor's chalk or soft pencil
Scissors
Cerise printing ink
Mixing bowl
Tablespoon
Metal or plastic tray
Felt
Shop-bought flower stamp
Masking tape
Two heart-shaped pastry cutters
2.5m (98in) bias binding or seam binding
Thread or staple gun and staples

1

Make a card template triangle – each side measuring 20cm (7¾in). Use your template to mark out your flags with tailor's chalk or a soft pencil. It's a good idea to cut a few extras for trials or in case of accidents. To make my fabric bunting last longer I've sewn a single row of machine stay-stitching all around the edges to prevent fraying (not necessary for paper triangles).

2

Mix the printing ink to the required colour. Spoon three tablespoons of ink onto your tray. Spread the ink over the base in a thick layer, leaving a gap around the edges. Cut a piece of felt slightly larger than the ink pool. Lay it on top of the ink. The slight over-sizing helps prevent ink from squirting out around the edges. Using the flower stamp, repeatedly stamp onto the felt until the ink is forced through to the surface.

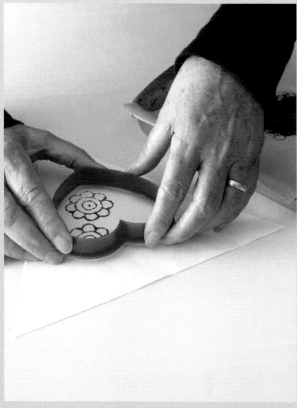

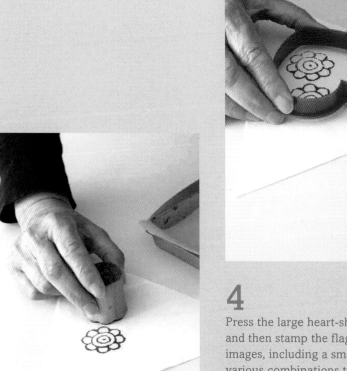

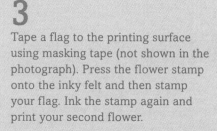

3

Tape a flag to the printing surface using masking tape (not shown in the photograph). Press the flower stamp onto the inky felt and then stamp your flag. Ink the stamp again and print your second flower.

4

Press the large heart-shaped cutter onto the inky felt and then stamp the flag. I have used three stamped images, including a smaller heart-shaped cutter, in various combinations to make the flags interesting and varied. Follow the designs shown here or enjoy experimenting. Allow the inks to dry before moving and fixing (see p.140). It is not necessary to fix the ink if you are making paper flags. If you wish to sew the bunting, place the top edge of a fabric flag into the fold of the bias binding. Pin in place before sewing. I placed the flags approximately 7cm (2⅜in) apart with 25cm (10in) at each end for tying. If you wish to staple fabric or paper flags, attach them to flat seam binding or tape.

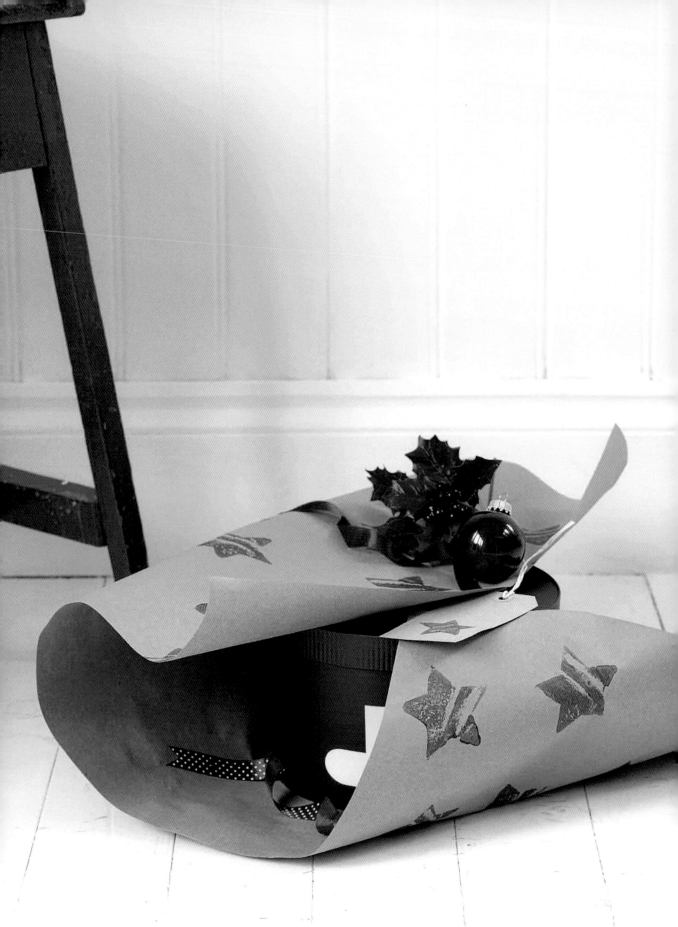

christmas stars

wrapping papers and gift tags

This simple potato-print design is an effective way to personalize wrapping paper and make a gift even more special. These printed papers and tags have been designed to coordinate with the Five Christmas Stars Gift Ribbons on p.18 – together, they make a gorgeous gift-wrap set. The textured mulberry paper is available from most art and craft shops.

two sizes of potato print on
two different papers with
matching tags

MATERIALS

Two potatoes
Kitchen paper
Craft knife
Cutting board
Marker pen (optional)
Red and grey printing inks
Mixing bowls
Tablespoons
Metal or plastic trays
Felt
Masking tape
Mulberry paper
Brown wrapping paper
Brown luggage tags

1

Choose a potato that is large enough for you to hold
comfortably. Wash it, dry it and cut it in half. Dab
the cut surfaces onto kitchen paper to absorb some of
the moisture. Using a craft knife on a cutting board,
cut a star shape into your potato (see p.14). You can
draw your design onto the potato with a marker pen
before cutting if you wish. For the mulberry paper
print, I have cut two different-sized stars on the
potatoes. Remember, the hand-cut quality and uneven
potato surface give character to these prints.

2

Prepare your ink tray. Mix the printing ink to the
required colour. Spoon three tablespoons of the first
colour onto a tray. Spread the ink over the base in a
thick layer, leaving a gap around the edges. Cut a piece
of felt slightly larger than the ink pool. Lay it on top
of the ink. The slight over-sizing helps prevent ink
from squirting out around the edges. Repeatedly stamp
your two potato stars onto the felt until the ink is
forced through to the surface.

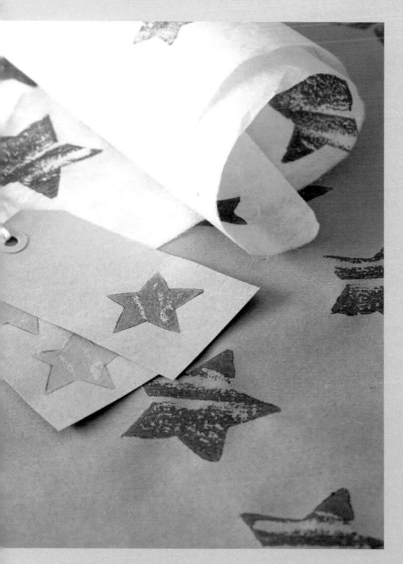

3

Using masking tape, fix the mulberry paper to the printing surface. Print your stars randomly over the paper. Recharge your potato stamps with ink every time you stamp the paper.

4

For the brown paper print, cut one potato star. Prepare a second ink tray (see step 2) with the second colour. Print the stars randomly on the paper.

5

Wait for the ink to dry before removing the paper from the printing surface.

6

Repeat the process with the coordinating tags. Enjoy printing a variety of combinations.

With a little imagination, you can cut potato shapes to suit other occasions. A heart for Valentine's Day, perhaps, or a simple X for a kiss.

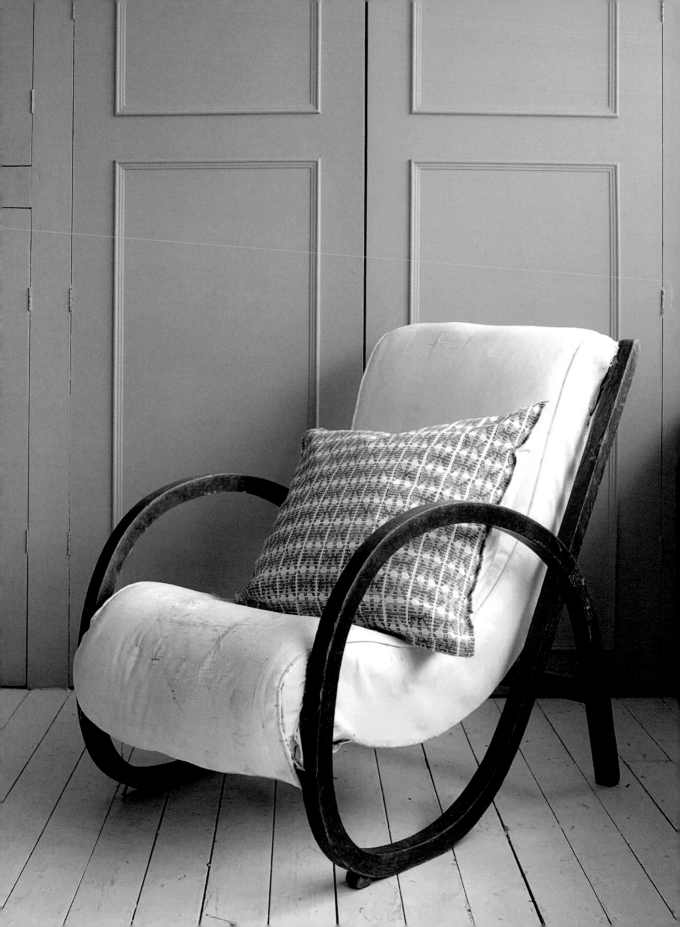

arts and crafts blockhead cushion

This design uses a shop-bought stamp and a hand-cut potato. The beauty of potato prints lies in the character of the hand-cut image, which can be a little uneven and imprecise. Designs like this are very personal and no two can ever be made to look identical. The choice of colours for your design will require careful thought.

combination potato and commercial stamp print in two colours

MATERIALS

Cushion cover
Needle and thread or tailor's chalk
Newsprint or similar
Masking tape
Yellow ochre and grey printing inks
Mixing bowls
Tablespoons
Metal or plastic trays
Felt
Shop-bought printing stamp
Spare piece of fabric for trials
Potato
Craft knife
Cutting board
Kitchen paper
Marker pen (optional)
Soft brush

1

Use guidelines for accuracy. Find the centre of your cushion cover by folding or measuring. Next, using running stitch or tailor's chalk, make a guideline from top to bottom and side to side through the centre point. You could also run a border guideline around the four sides, 2cm (¾in) in from the edge. Don't knot the beginning or the end of the thread. Place two or three sheets of newsprint or similar inside the cushion cover. This prevents the printing ink passing from the front cover to the back cover.

2

Fix the cushion cover to the printing surface using masking tape. The fabric should be flat and smooth but not stretched.

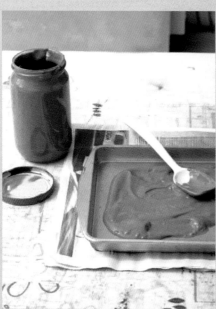

3

Mix the printing inks to the required colours, following the manufacturer's instructions. Spoon three tablespoons of the first colour onto a tray. Spread the ink over the base in a thick layer, leaving a gap around the edges.

4

Cut a piece of felt slightly larger than the ink pool. Lay it on top of the ink. The slight over-sizing helps prevent ink from squirting out around the edges. Using the printing stamp, repeatedly stamp onto the felt until the ink is forced through to the surface.

5

Do some trial stamps onto a spare piece of fabric until you achieve a clear image.

6

Print down and across one quarter of the fabric, following your guidelines. Keep to the sides of the thread and check that your spacing is even. Do not print over seams or turnings.

7

Fill in the four sections of the fabric. Stand back occasionally to check that your lines are straight and that your spacing is even. Allow the ink to dry and remove the guide stitching by pulling through.

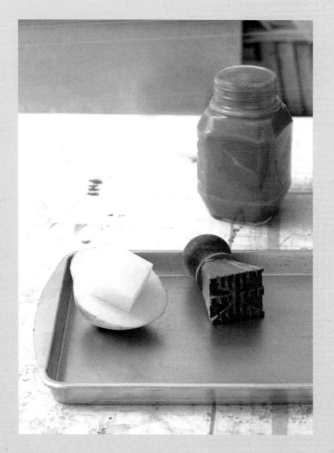

If a ridge of ink collects on the side of the stamp, wipe with a piece of kitchen towel. This will prevent smudges from spoiling your work.

8

Cut your potato shape (see p.14) using a craft knife on a cutting board. Choose a potato that is large enough for you to hold comfortably. Wash it, dry it and cut it in half. Dab the cut surfaces onto kitchen paper to absorb some of the moisture. You can draw your design onto the potato with a marker pen before cutting if you wish. I made this shape slightly smaller than the stamp size so that it fits neatly inside the first image when it is printed.

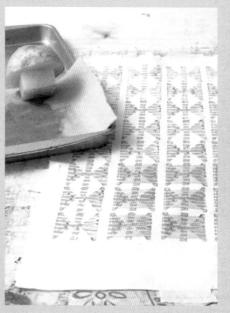

9

Repeat steps 3–7 using your second colour and the cut potato. If your potato block starts to break down, cut another one. Allow the fabric to dry before moving and fixing (see p.140). Clean the printing stamp with a soft brush and soapy water.

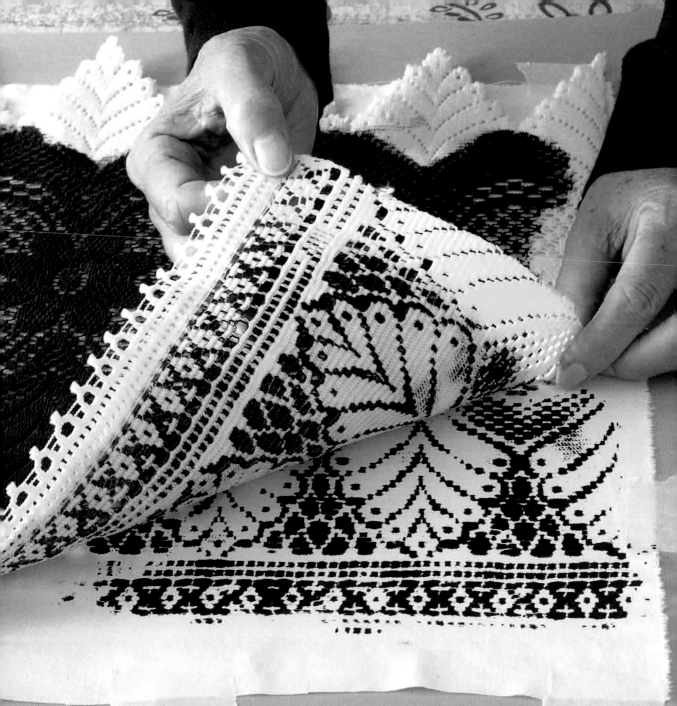

sponging
& stencils

Hand-cut stencils are a great way to produce unique designs. The lines are cleaner than those made by potato prints, and, with practise and imagination, your designs can become accurate and complex. Your stencil – essentially anything that you can push ink through – can be made at home using firm card (cereal packets are ideal). Experiment with different types of sponges – I've used a holey, natural sponge – and alter the texture by varying the amount of pressure you use.

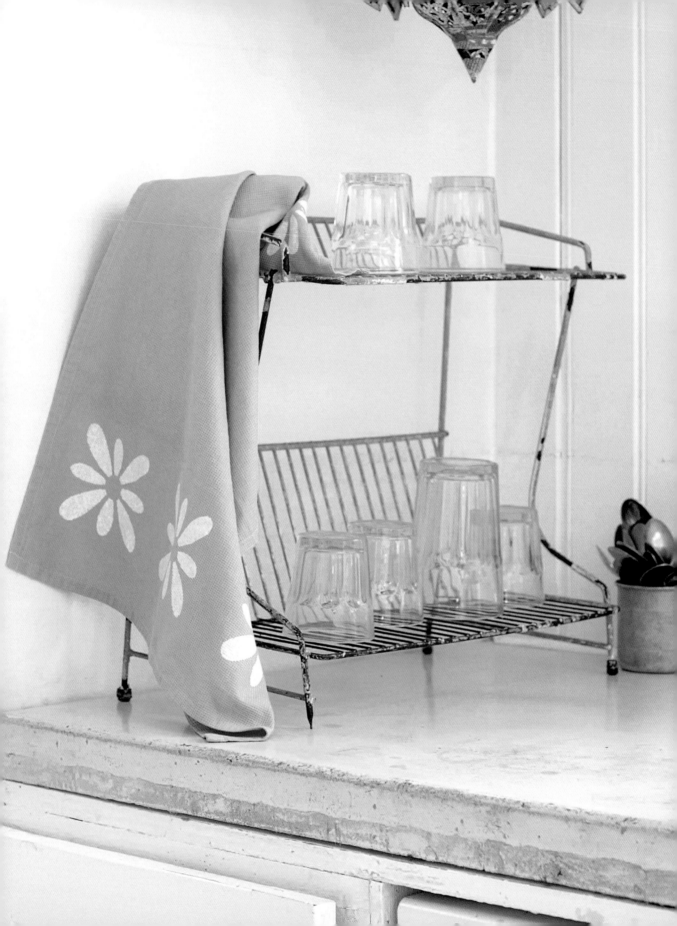

upcycle project daisy
border
tea towel

I can't promise to make drying-up a pleasure,
but it seems reasonable to use tea towels that you
actually like! Using a hand-cut stencil with a simple
floral motif, this single-colour print takes only
moments to produce and could be the start of a
complete kitchen makeover.

hand-cut flower stencil with single colour sponged through

MATERIALS

Card
Craft knife
Cutting mat
Tailor's chalk or soft pencil
Tea towel
Masking tape
Opaque white printing ink
Mixing bowl
Tablespoon
Metal or plastic tray
Sponge
Kitchen paper or newspaper

1

Use the template (see p.138) or draw/trace your own design onto card.

2

Cut out the design using a craft knife and cutting mat. Leave enough card around the design to enable you to hold it while you are printing.

3

Mark 'T' for the top of the design on the card to ensure you always place it the same way up.

The printing technique used here would work equally well on old tea towels that simply need a little cheering up.

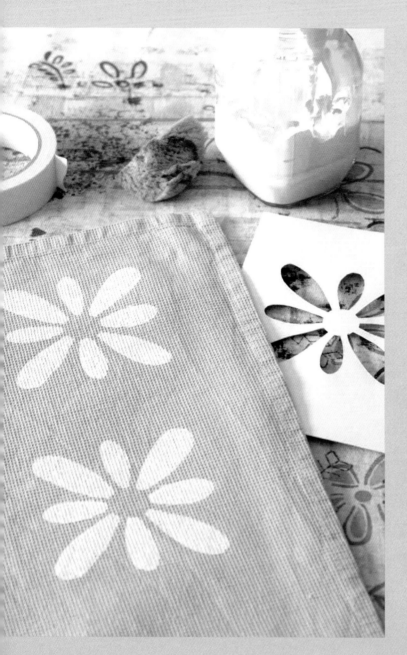

4

If you need guidelines for printing, chalk a straight line onto the tea towel (tailor's chalk brushes away). Alternatively, cut your card to line up with the top edge of your tea towel. My tea towel measures 66 x 42cm (26 x 16½in); the design is printed 4cm (1½in) down from the top edge, and starts 2cm (¾in) in from the side edge.

5

Hold your stencil in position or use masking tape.

6

Mix your ink and place three tablespoons onto the tray, leaving space for dabbing off.

7

Dab your sponge into the ink and dab again onto the tray before dabbing onto the stencil. This ensures that the sponge is not too heavy with ink and allows the colour to build gradually.

8

If the ink spreads to the back of the stencil, blot it between sheets of kitchen paper or newspaper before laying it onto the fabric again.

9

If your stencil gets soggy, cut another one. It's worth it!

10

Allow the ink to dry before moving and fixing (see p.140).

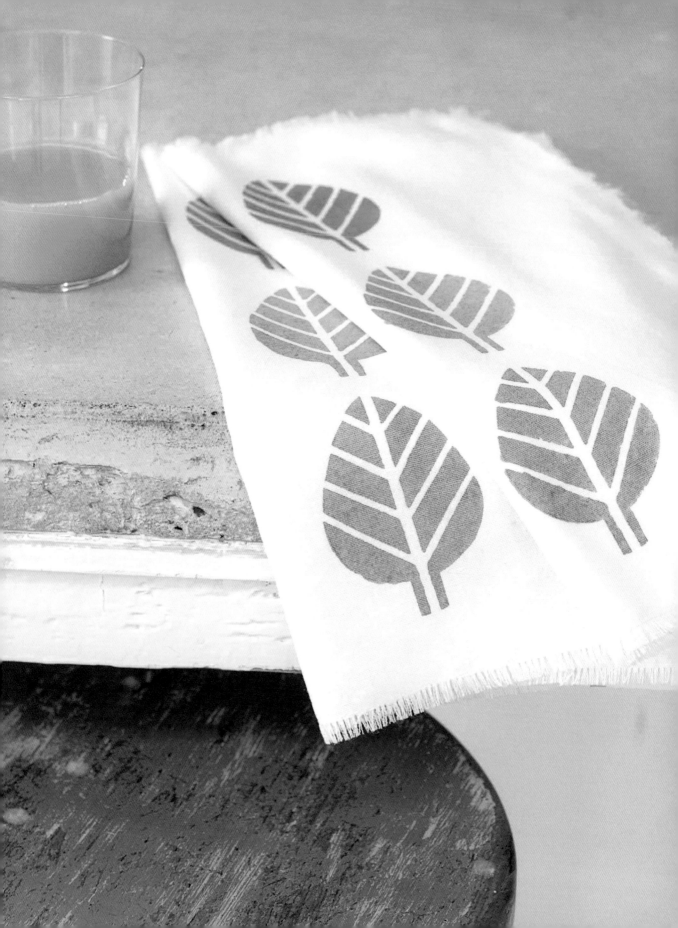

autumn leaves napkins

Celebrate the seasons with these leafy, linen napkins, created using sponges and stencils. They can make a simple meal special on a table for two. You can print your design on ready-made napkins, or make your own using the simple instructions on the following pages.

hand-cut stencil with two colours sponged through

MATERIALS

Card
Craft knife
Cutting mat
Two napkins/fabric and thread
Masking tape
Tailor's chalk or soft pencil
Green and orange printing inks
Tablespoon
Mixing bowl
Metal or plastic trays
Sponge
Kitchen paper or newspaper

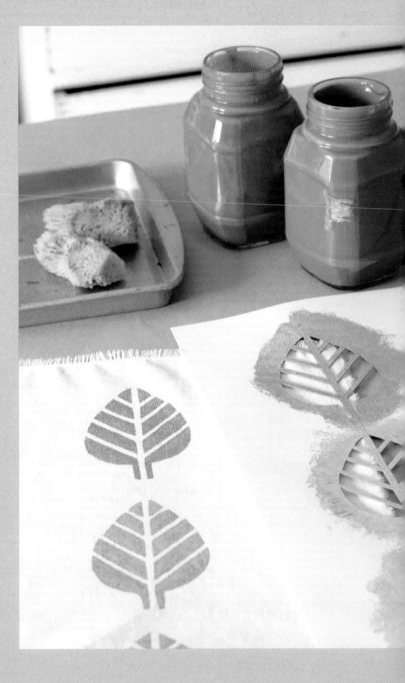

Try printing your design onto a coloured fabric – it could add even more interest to your finished napkins.

If you don't want to work on a white background, you could always try some home-dyeing before you print!

1

Use the template (see p.139) or draw/trace your own design onto card.

2

Cut out the design using a craft knife and cutting mat. Leave enough card around the design to enable you to hold it while you are printing.

3

Fix the napkin or fabric onto the printing surface using masking tape. My fabric measures approximately 48 x 37cm (19 x 14½in); the design is 10cm (4in) from the top edge and 2cm (¾in) in from the side edge. If you are using ready-made napkins, do not print over the thick, hemmed edges.

4

Use tailor's chalk or a soft pencil to mark guidelines if required. Alternatively, place the edge of your stencil along the edge of the napkin to ensure you print in a straight line.

5

Mix the ink for your first colour and place three tablespoons onto the tray, leaving enough space for dabbing off. Dab your sponge into the ink and dab again onto the tray before stencilling. This ensures that the sponge is not too heavy with ink and allows the colour to build gradually.

6

If the ink spreads to the back of the stencil, blot it between sheets of kitchen paper or newspaper before laying it onto the fabric again. If your stencil gets soggy, cut another one. Always remove stencils carefully.

7

Allow the first colour to dry. Cut a new stencil and repeat steps 4–6 using the second colour. Allow the ink to dry before moving and fixing (see p.140).

8

To finish the edges of the linen napkin, if making your own, machine a double row of stitching around the four sides, 1.5cm (½in) in from the edges. Tease out the long threads of fabric on the outside of the machine stitching to create a fringed effect.

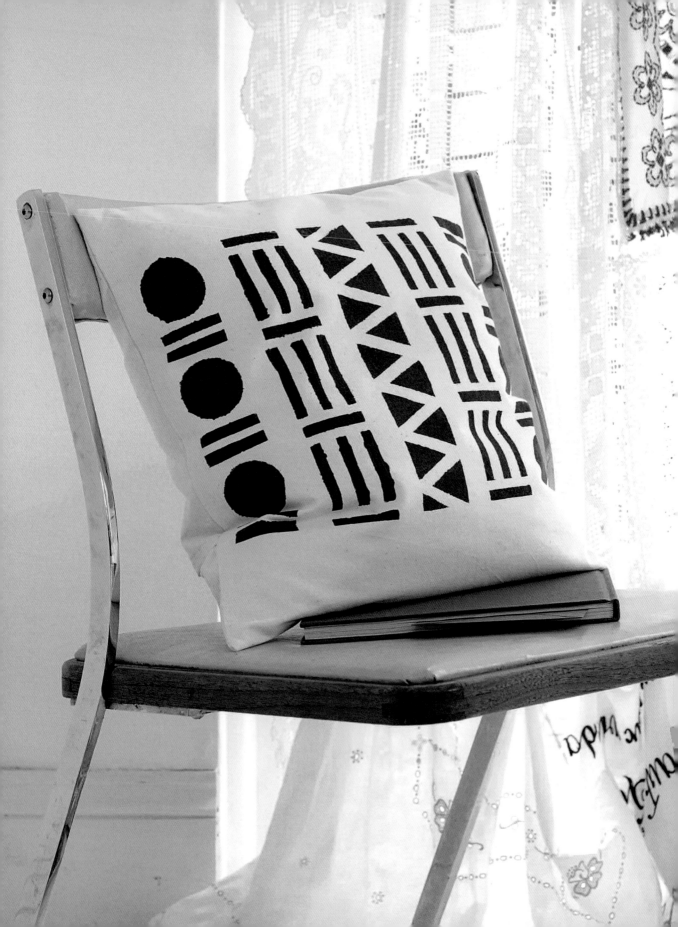

kind of
blue
cushion

This bold design requires a degree of accuracy
to ensure a good result. The stencils need to
be planned so that they fit attractively onto the
cushion cover within the available space. If you
use a ready-made cover, adjust the measurements
as required. My finished cover is designed to be
used with a standard 40 x 40cm (15¾ x 15¾in) pad.

three hand-cut stencils with single colour sponged through

MATERIALS

Card
Craft knife
Cutting mat
Newsprint or similar
Cushion cover
Masking tape
Tailor's chalk or soft pencil
Denim blue printing ink
Mixing bowl
Tablespoon
Metal or plastic tray
Sponge
Kitchen paper

1

Use the templates (see p.136) or draw/trace your designs onto card, using a cutting mat and a craft knife to cut the card. My three card pieces are 10 x 32cm (4 x 12½in). This allows for a design area that measures approximately 5 x 25cm (2 x 10in), plus 2cm (⅜in) top and bottom for the gaps between the printed strips. Mark your stencils with 'T' at the top to ensure that you place them correctly. Place two sheets of newsprint or similar inside the cushion cover so that the printing ink doesn't spread through from the front to the back. Fix the cushion cover to the printing surface using masking tape. Using the edge of the fabric as a guide, or a guideline of tailor's chalk, place your first stencil onto your fabric. Lightly tape in place.

2

Mix the ink and place three tablespoons onto the tray, leaving space for dabbing off.

3

Dab the sponge into the ink and then onto the tray, and then dab onto the first stencil. Work from one end to the other. Hold the stencil flat with your free hand if necessary. Allow the colour to build gradually, constantly recharging and dabbing off the sponge. Carefully remove the stencil.

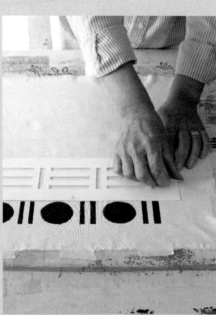

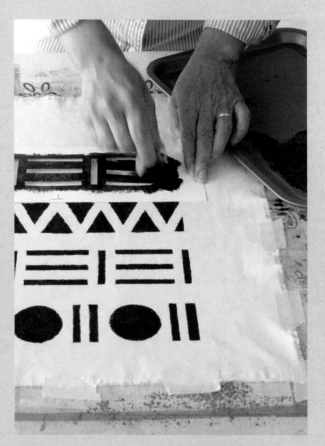

4

Allow the first printed area to dry. Place the top of stencil 2 in line with the bottom of the printed edge of your first stencil. Sponge ink through and allow to dry. Place the top of stencil 3 in line with the bottom of the printed edge of your second stencil. Sponge ink through and allow to dry.

5

Using stencil 2 again, print the fourth line of the design, checking first that ink has not spread through to the back of the stencil. Blot the stencil between pieces of kitchen paper if necessary. Finally, using stencil 1, reverse it top to bottom and place in position for the fifth line of your print. Sponge ink through. Carefully remove your stencil. Allow the ink to dry before moving and fixing (see p.140).

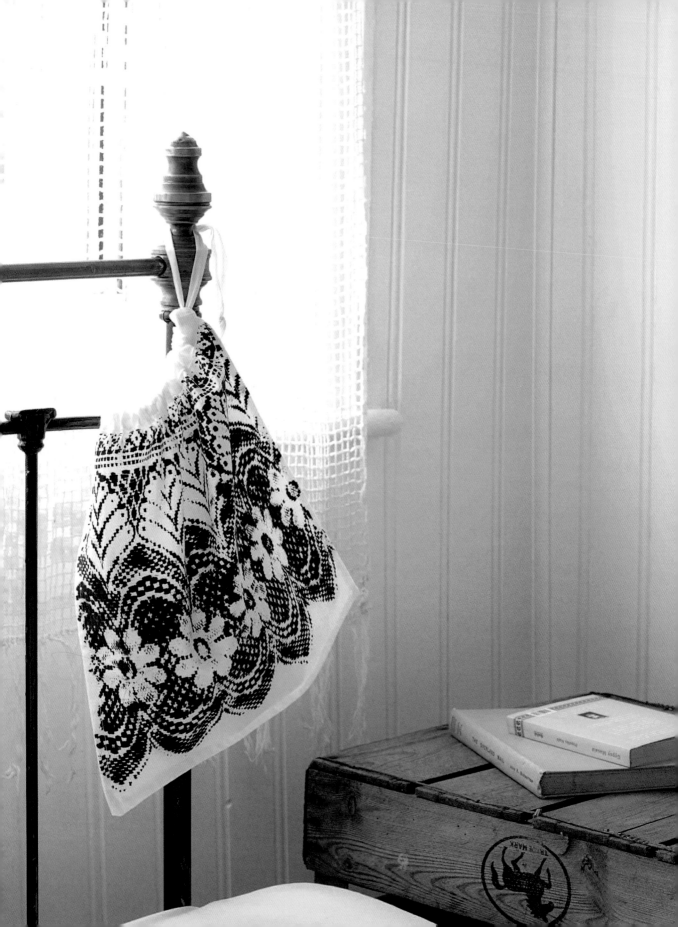

lacy-look
bits bag

I was searching around for objects that I could print through – anything with holes is worth a try! This lace print worked so well I thought I should include it here. The black-on-white combo creates a strong image. If you'd like a 'prettier' result, try soft pastel colours instead.

heavy curtain lace stencil with single colour sponged through

MATERIALS

Newsprint or similar
Small drawstring bag or similar
Masking tape
Lace
Black printing ink
Mixing bowl
Tablespoon
Metal or plastic tray
Sponge

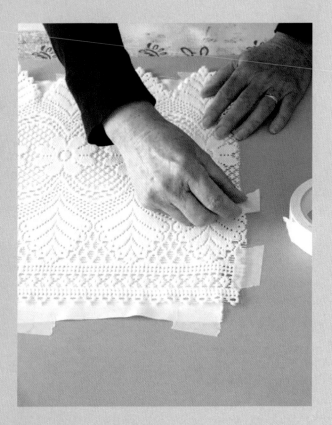

1

Place several sheets of newsprint or similar inside your bag to prevent ink spreading from the front to the back (this printing method produces a heavy ink deposit). Fix the bag to the printing surface using masking tape. Lay the lace over the bag and use masking tape to hold it in position. For an all-over design, it's best to use a single piece of lace that is large enough to fit over the bag (you really don't want to keep moving inky, wet lace!). This method also works if you use a narrow strip of lace to print a border.

If the lace that you use is too fine, you will lose the detail in the design.

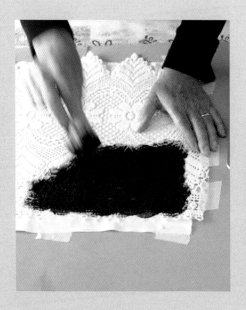

2

Mix the ink and place three tablespoons onto the tray, leaving enough space for dabbing off. Using the inky sponge, dab the ink through in small sections at a time. You need to press the sponge firmly as the lace fabric itself soaks up a lot of ink. Use your spare hand to hold the lace close to the fabric as you move to each section.

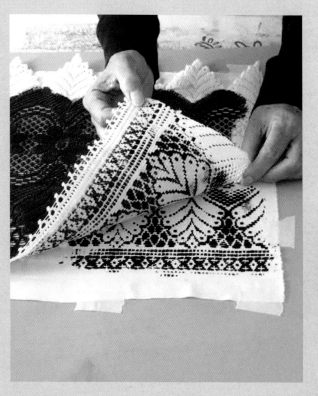

3

Carefully remove the wet lace. Allow the fabric to dry before moving and fixing (see p.140).

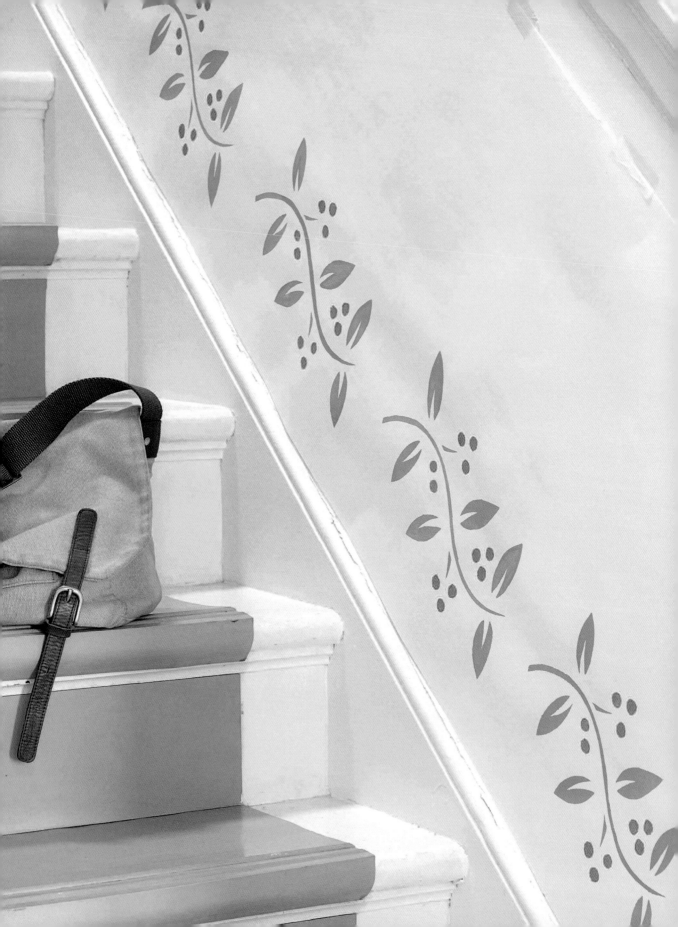

blue and orange wall stencil

I've used emulsion paints for this wall stencil – the colours available are infinite, and the little tester pots are very cheap. Stencils look good as a frieze at any height around a room. Try framing a curtainless window or print across the top of a door frame. Finding new places to print is easy – it's stopping that's the problem!

hand-cut stencil with two colours sponged through

MATERIALS

Card
Craft knife
Cutting mat
Two colours of emulsion paint
Tablespoon
Mixing bowls
Metal or plastic trays
Masking tape
Small pieces of sponge
Newsprint or kitchen paper

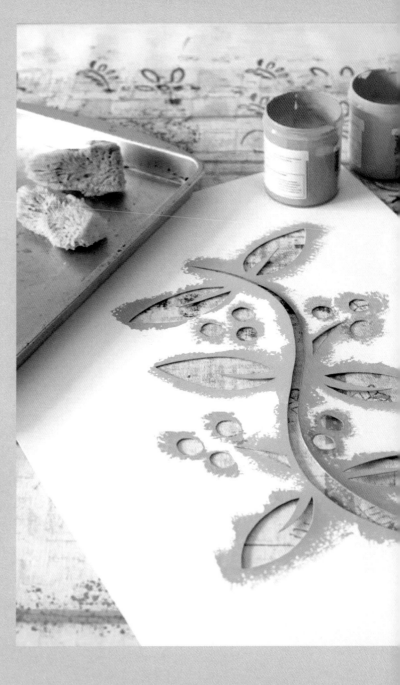

Before buying new colours for your design, experiment with paint left over from the last time you decorated.

1

Use the template (see p.138) or draw/trace and cut your own design using a craft knife and cutting mat.

2

Place two tablespoons of your first colour of emulsion paint onto the tray. (This is the stem colour.)

3

Fix the stencil into position on the wall using masking tape.

4

Use a small piece of sponge for accuracy. Dab the sponge into the paint, dab off onto the tray, then dab the colour onto the stencil. Allow the colour to build up gradually. As you progress across the image, use your spare hand to press the stencil against the wall to ensure that your printed image is sharp.

5

Carefully remove the stencil and allow the paint to dry.

6

Blot the stencil with kitchen paper and allow it to dry. If your stencil becomes too soggy or soft, stop using it and cut another one.

7

Place two tablespoons of the second colour onto a clean tray, leaving space for dabbing off.

8

Fix the stencil to the wall again over the first printed area, matching the lines of the stem.

9

Dab the second colour through the stencil to print the berries. Carefully remove the stencil. This stencil design can be repeated and reversed for a continuous print.

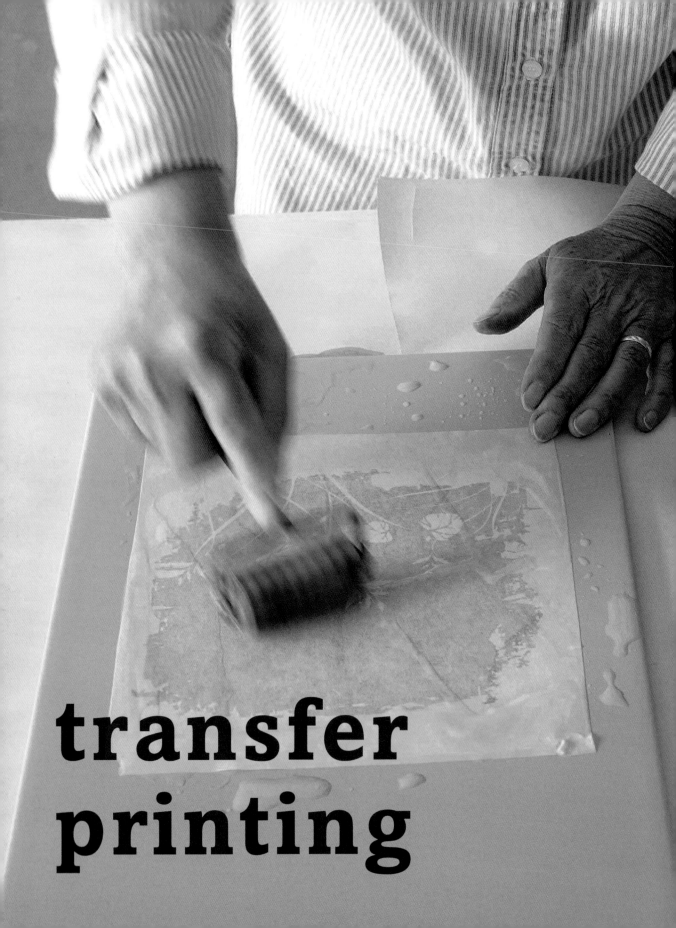

transfer
printing

This chapter is full of inspiring ways to transfer images – whether it's your own drawing, a photograph or a picture from a magazine. Copyright-free pictures can be purchased from stock photo websites to use for your design. If you transfer a copyrighted image, remember that it shouldn't be used for commercial purposes. The tools needed for transfer printing range from a wax crayon to an Apple Mac computer, and there really is no limit to the possibilities.

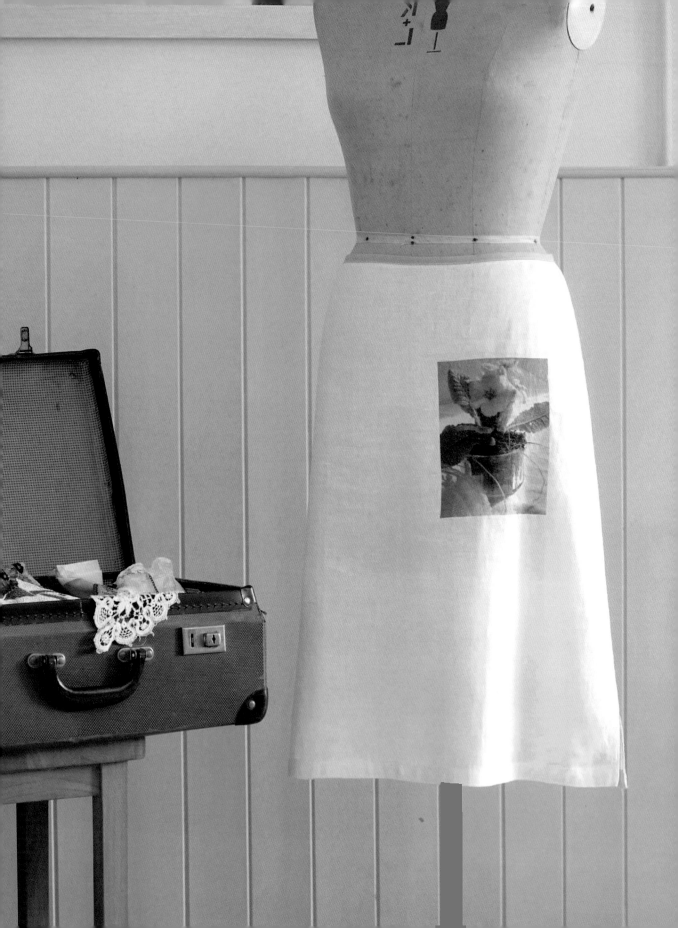

upcycle project sepia tint primrose skirt

Why let photos languish in an album when you can display them on your clothes? If you take lots of digital photos, it's a great idea to single out favourites for special treatment. This plain linen skirt has become much more interesting now that it's personalized with a picture.

heat transfer digital photo
with plant image

MATERIALS

Digital camera
Computer and software
Image transfer paper
Printer
Garment of your choice
Scissors
Iron and ironing board

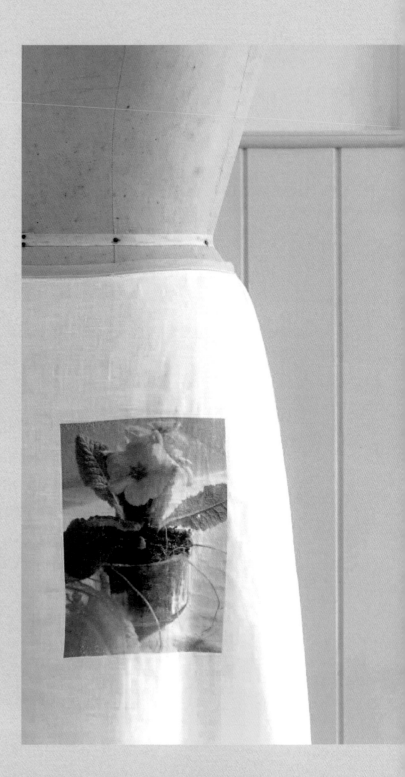

There are several types of transfer paper available. Some are best for use on natural fabrics and some on acrylics or a mix of the two. Check that you use the correct one for your chosen garment.

1

Decide on your image and take a digital photograph. I chose to use a picture of a primrose plant with its roots and soil in a glass pot.

2

Download the picture onto your computer.

3

Check the size of the downloaded image from your camera and calculate the percentage reduction needed to print at your chosen size. My primrose image is printed at 18 x 13cm (7 x 5in).

4

Convert the image into black and white.

5

'Flip' the image so that it doesn't print as a mirror image.

6

Follow the manufacturer's instructions for inserting image transfer paper into your printer, and print out the photograph.

7

Follow the manufacturer's instructions for heat transferring the image onto the fabric. After trimming with scissors, mine was ironed on and I deliberately overheated the image to scorch it slightly, giving it a sepia tint.

ceramic
tile
print

The technique used to create this fragile and magical image does not require a computer, just a black-and-white photocopy and a solution of white spirit and soap. This printing method is very hands-on, takes very little time, and each image produced is unique.

black-and-white photocopy transfer

MATERIALS

Screw-top jar
White spirit
Water
Liquid soap
Good-quality black-and-white photocopy
Large tray or dish (oven dish)
Tile
Lino print roller

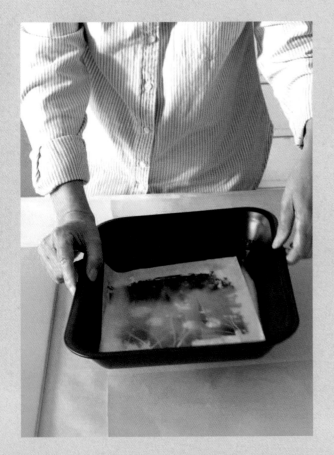

1

Using a screw-top jar, mix the following solution: one third white spirit, two thirds water, and several squirts of liquid soap. With the lid on the jar, shake vigorously to mix. Place the black-and-white photocopy into the large dish. Pour in enough of the solution to completely cover the photocopy. Swirl the solution in the dish until the photocopy is thoroughly soaked. Take care not to disturb the photocopy ink.

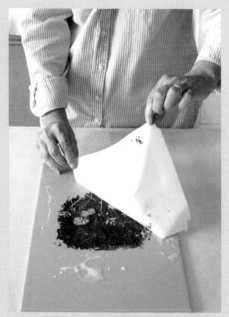

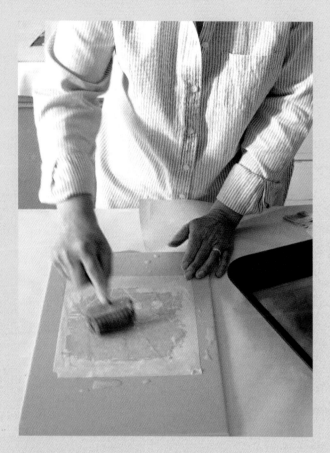

3

Gently lift one corner of the paper occasionally to check progress. When the transfer is complete, carefully peel away the paper and allow the tile and image to dry.

2

Lift the wet photocopy carefully from the dish and lay it ink-side down onto the surface of the tile. Gently use the roller to flatten the paper completely. Continue rolling over the whole surface of the photocopy for several minutes. This will transfer the black image onto the tile.

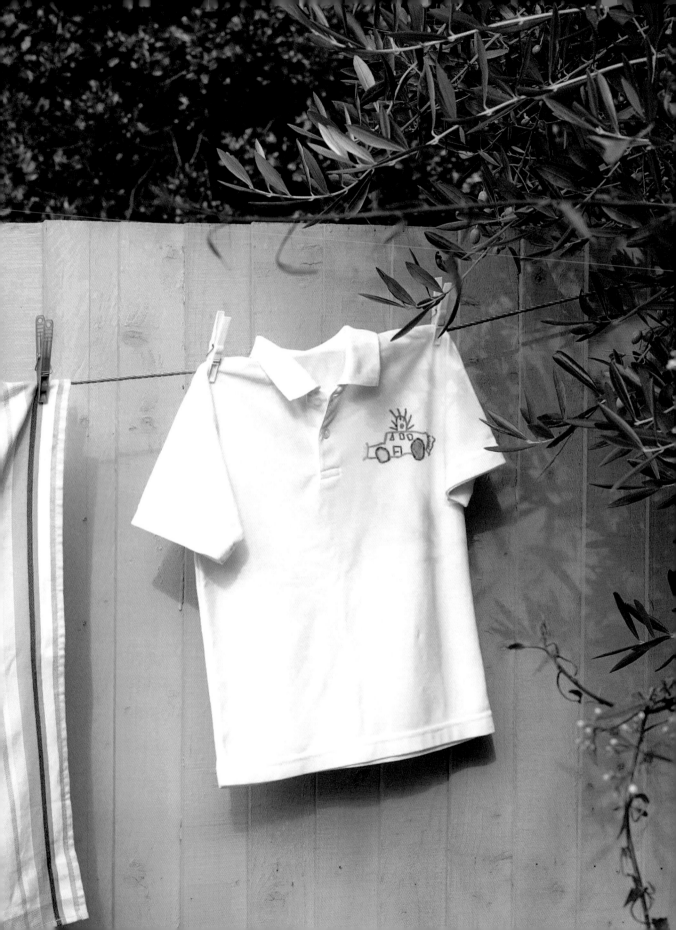

upcycle project decorated
child's
t-shirt

Transfer a special picture onto a t-shirt and it
can be worn with pride. This design has been
achieved using transfer fabric crayons. I've used
a child's drawing – a great way to personalize
their clothes. This is also a really good idea for
easy-to-produce team or club logos.

image transfer of a child's own drawing

MATERIALS

Child's drawing on non-glossy paper
Transfer fabric crayons
Newspaper
Newsprint or similar
Child's t-shirt
Iron

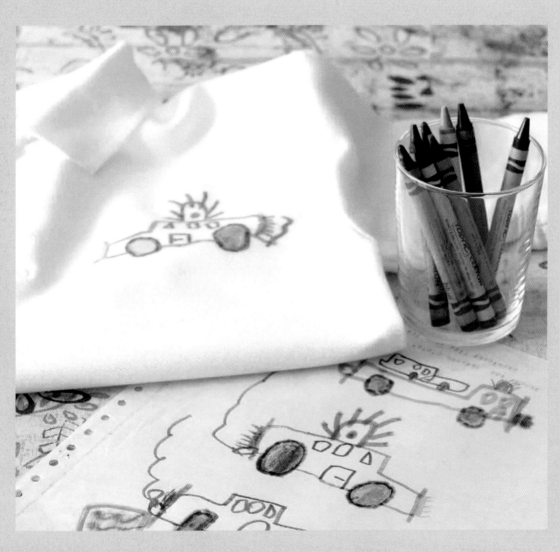

Make a lovely gift for grandparents by transferring a child's drawing onto a cushion cover or an apron.

1

The design needs to be drawn onto non-glossy drawing paper. (I used Crayola Transfer Fabric Crayons – if you use a different product, follow the manufacturer's instructions.)

2

Brush any excess crayon specks from the design.

3

Prepare an ironing pad using several layers of newspaper topped with unprinted newsprint or similar.

4

Place the t-shirt (this product recommends one made of at least 50 per cent synthetic fibre, and pre-washed) on top of the ironing pad. Place newsprint between the front and back of the t-shirt to prevent colours from transferring to the back.

5

Lay the paper design face down onto the t-shirt. Lay a clean sheet of newsprint between the iron and the paper design to protect the iron and the garment.

6

Use a 'cotton' setting on your iron – hot and dry (no steam). Iron with a steady pressure over the entire surface of the paper design until the image becomes slightly visible through the paper. Be careful not to scorch the fabric.

7

Remove the paper design carefully. The design can be re-crayoned and used again.

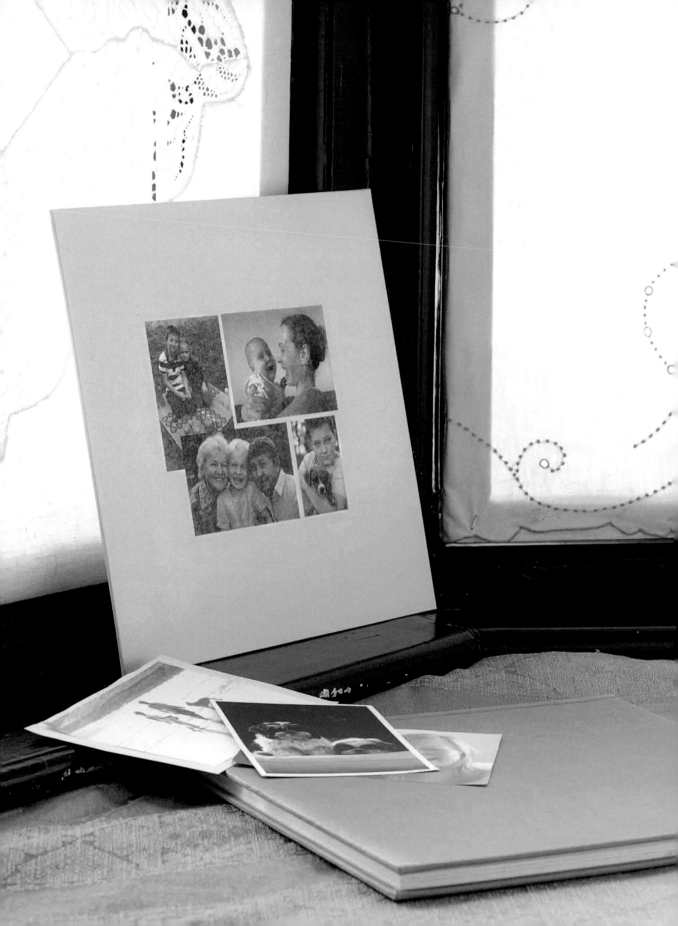

photo
montage
wall art

Your photographs can look as good as a painting when you transfer them onto an artist's canvas. Once you've selected the images you want for your montage, you could either colour-photocopy from the prints themselves, or print them out as a montage using Photoshop. The magic in the transfer technique is image transfer paste – widely available from art and craft shops.

friends/family photo transfer, applied to artist's canvas

MATERIALS

Group of much-loved photos
Computer and software (if you wish)
Colour photocopy
Scissors
Metal or plastic tray
Image transfer paste
Paint brush
Flat artist's canvas
Kitchen paper
Rolling pin
Sponge

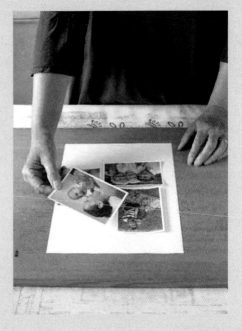

1

Prepare the photo montage. Choose your photos and arrange them into a good composition. I used Photoshop on an Apple Mac computer for this stage, and printed out my finished design. This print is then colour-photocopied. Alternatively, you can print a colour copy directly from your photographs. Trim the photocopy to the required size.

2

Place the photocopy of your photo-montage printed-side up into the metal tray. Squeeze a generous amount of image transfer paste onto your picture and spread it evenly over the picture surface using a clean paint brush. The image transfer paste needs to be thick enough so that the picture cannot be seen clearly.

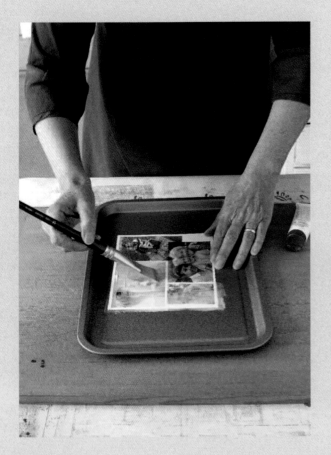

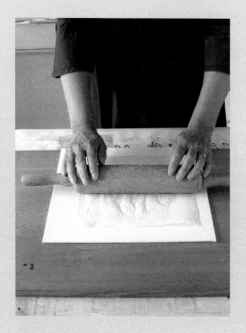
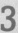

3

Carefully lift your wet picture and place it paste-side down on the artist's canvas. Press it down evenly to ensure there are no wrinkles. Place kitchen paper over the photocopy and, using a rolling pin, roll gently in alternate directions for one minute. This lightly presses the transfer onto the canvas and ensures that the edges are adhered.

4

Remove the kitchen paper and blot any excess paste. Allow the transfer to dry thoroughly, preferably overnight. Place a water-soaked sponge onto the dry transfer and allow it to soak until the paper is soft. Using your finger or the sponge, begin gently rubbing in the centre of the transfer until the paper can be rolled off. Continue until all of the paper is removed. Leave to dry. If you wish to seal your transfer, place a few drops of image transfer paste onto the transfer and rub gently, using a clean brush or scrap of material, over the entire image surface. Allow to dry thoroughly.

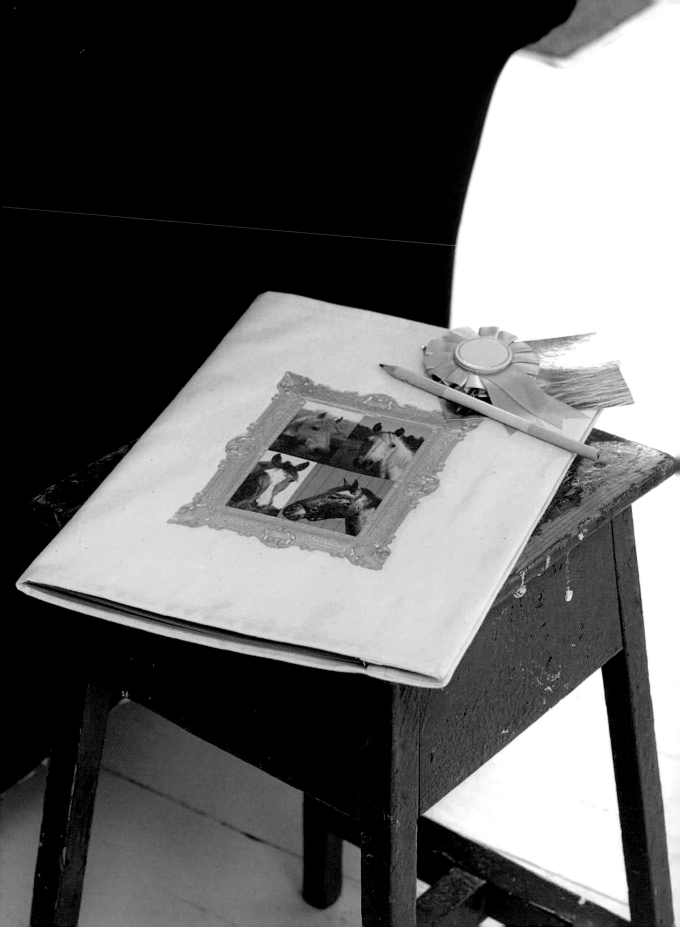

hobby-themed scrapbook cover

There's something about a scrapbook that seems to bring out the hand-made devotee in us all. This transferred image could be printed directly onto the scrapbook cover. If you want to go that extra mile, follow the instructions here for the calico loose cover. This technique is also good for personalizing photo albums.

image created using transfer paper

MATERIALS

Favourite hobby pictures
Image scanner
Computer and software
Printer
Image transfer paper
Calico and thread
Iron-on hemming tape (optional)
Scrapbook

1

Scan your chosen pictures or search stock photo websites and download.

2

Using image manipulation software (e.g. Photoshop), arrange the pictures and scale them to the required size.

3

Choose a frame image from a stock photo website. Change the colour to one that you like. Combine the photo image and the frame image, adjusting measurements to fit. Remember to flip the image.

4

Print the image onto image transfer paper following the manufacturer's instructions.

5

To prepare the calico cover for your scrapbook, follow the separate instructions given on the opposite page.

6

Following the manufacturer's instructions, apply the image to the calico loose cover using heat transfer.

7

Alternatively, transfer the image directly onto the scrapbook cover.

to make the calico loose cover

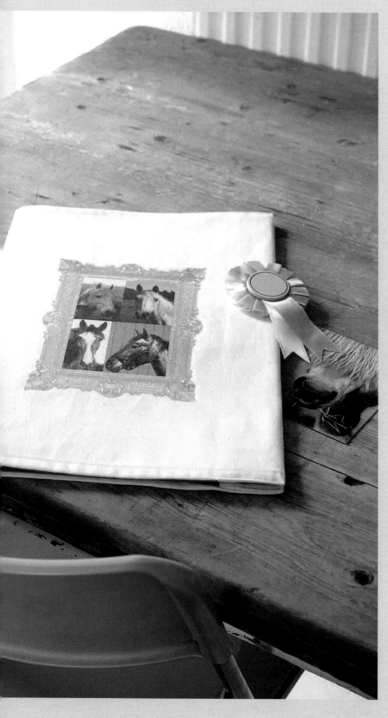

1

With the scrapbook laid open, measure the front and back. Add 2cm (¾in) at the top and bottom for turnings, and add 7cm (2¾in) to both sides for fold-back and turnings. Cut a piece of calico to this size.

2

The front and back of my scrapbook measures 35 x 50cm (13¾ x 19½in) – the front cover is 35 x 25cm (13¾ x 10in), and the back cover is 35 x 25cm (13¾ x 10in). With the turnings added, my piece of fabric measures 39 x 64cm (15½ x 25in).

3

Roll over the top edge twice and machine a hem. Alternatively, use iron-on hemming tape. Repeat along the bottom edge.

4

Hem both side edges in the same way.

5

Print the transferred image centrally on the front half of the cover, within the 35 x 25cm (13¾ x 10in) space.

6

Fold back the extra 5cm (2in) along the front edge and machine-stitch it in place along the top and bottom edges. Repeat for the back cover fold.

7

Slip the scrapbook into the loose cover.

**open
screen**

Screenprinting is a technique in which ink is passed through a screen or mesh that has been stretched onto a frame. The projects in this chapter are all produced using an 'open screen' technique – where areas of the open mesh are blocked to produce a design. With this method, printing ink is forced through the mesh using a squeegee. Ink cannot penetrate the areas of the mesh that are blocked. You can create endless designs using this technique, as you will see from the examples in this chapter.

an introduction to screenprinting

MATERIALS

Newsprint or similar
Screen with mesh
Gum strip
Bowl of water
Soft cloth
Spare piece of fabric for trials
Masking tape
Printing ink
Tablespoon
Squeegee
Plastic spatula
Hose
Sponge
Soap

preparing the screen

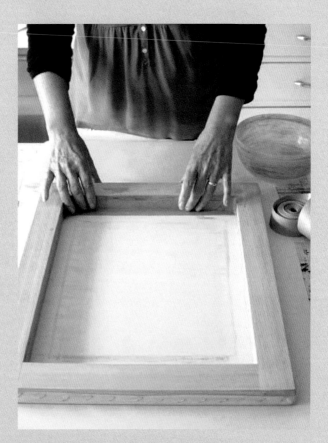

1

Lay several sheets of clean, absorbent paper (newsprint or similar) onto a flat surface. Lay the screen onto the paper, mesh-side down. The right-angle where the mesh meets the inside edge of the frame needs to be blocked, or ink will squirt through when you are printing. Tear off a piece of gum strip the length of one side of the screen. Wet it by dipping it, from one end to the other, into the bowl of water. Lay the wet gum strip so that it is half on the mesh and half on the frame. Press it gently into place using both hands, and dab off excess water with a soft cloth. Apply gum strip to the remaining three sides in the same way.

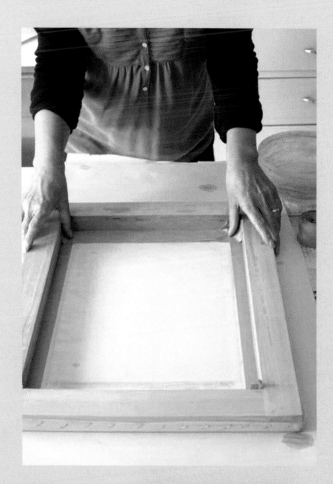

2

A second length of gum strip is now applied to all four sides. This strip lies flat on the mesh, overlapping the edge of the first strip.

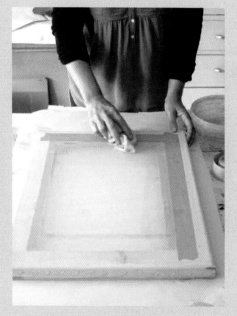

3

Turn the screen over and apply gum strip again on all four sides. The wet gum strip is laid flat over the point at which the mesh meets the inside edge of the frame. Allow all the gum strip to dry. Lay a piece of trial fabric onto the printing surface and fix in place with masking tape.

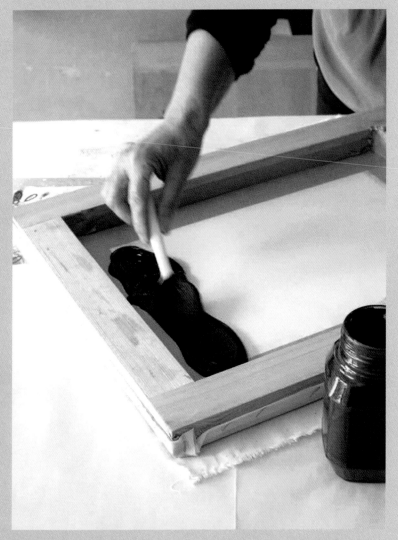

4

Turn the screen back over, mesh-side down, onto the fabric. Place four tablespoons of printing ink at one end of the screen. Spread the ink to cover the width of the screen.

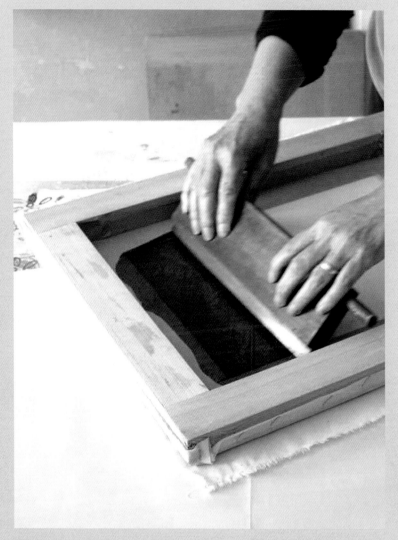

If you leave ink to dry on the screen it will block the mesh. After printing, use a plastic spatula to collect carefully any residue of ink on the screen. You can keep this mixed ink in a screw-top jar and use it again. Be careful not to tear the gum strip – if it becomes damaged it must be replaced before the screen is used again.

Ideally, the best way to clean a screen is in a large sink with a cold water spray. A hosepipe in the garden is just as effective. Alternatively, use a large sponge and cold water to remove any remaining ink residue. Wash the mesh again with a sponge and cold, soapy water. Rinse and allow to dry.

5

Choose a squeegee that is long enough to fit the full width of the printing area of the screen (that is, the area inside the gum strip 'frame'). Place the squeegee behind the ink pool and hold it at an angle of 45 degrees. Using both hands evenly spaced, press down firmly and pull the squeegee towards you. This action drags the ink across the screen and pushes it through the mesh. Make sure that you have enough ink to print the full length of the screen. This is called a 'wet pull'. A 'dry pull' is made by placing the squeegee in front of the ink pool and pulling across the wet screen. If the screen is large, you will need an assistant to hold the screen frame while you 'pull', to stop the screen from moving. If you are using a small screen, you can hold the squeegee with one hand and the screen frame with the other.

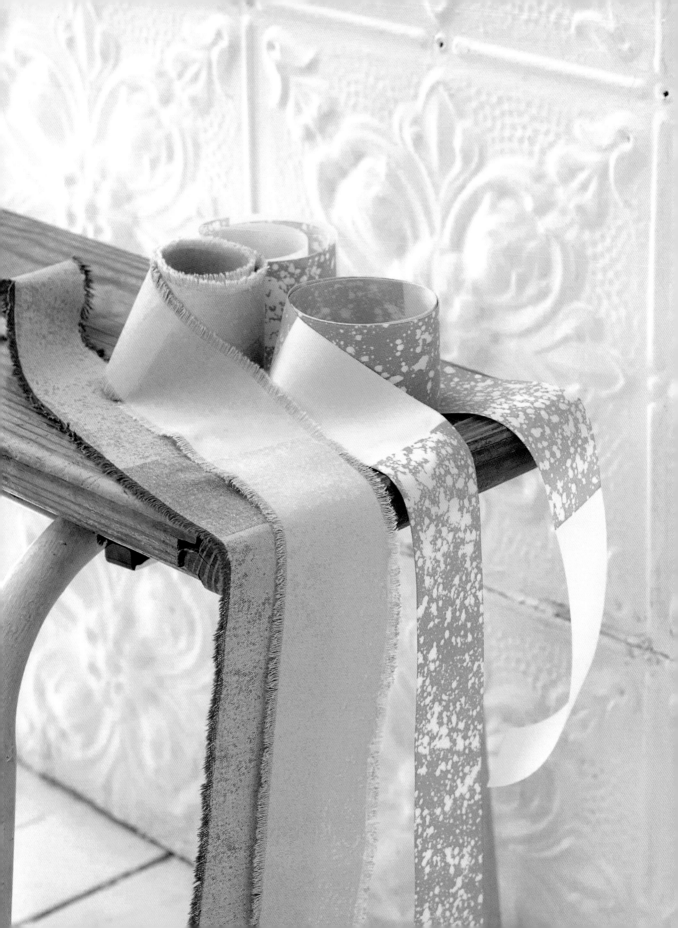

upcycle project sprinkle-pattern rainbow ribbons

This project employs a simple technique that produces a very decorative effect for gift wrapping. I've used two wide satin ribbons, but I've also suggested using your own 'rag' ribbons to make them truly personal. The uneven, frayed edge of rag ribbons contrasts well with shop-bought satin ones. Try using perfumed talcum powder so that your ribbons will smell good too!

screen blocked with talcum powder

MATERIALS

Two wide satin ribbons
Two home-made cotton rag ribbons
Masking tape
Talcum powder
Prepared open screen
Gold and blue printing inks
Tablespoon
Squeegee
Soft brush

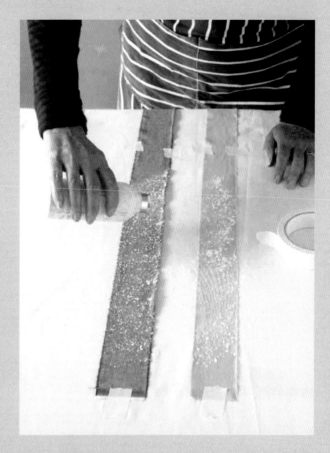

1

Cut four ribbons, approximately 2.5 x 100cm
(1 x 39in), two of which being the satin ribbons and two
of them your cotton rag ribbons. The four ribbons can
be printed one at a time, but if you are using the same
colour to print, they can be laid out next to each other.
Fix the two rag ribbons to the printing surface with
masking tape at each end. Sprinkle talcum powder
generously over the ribbons. Remember that the areas
covered with talcum powder will not be printed.

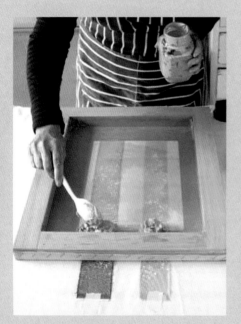

2

Lay the prepared screen (see p.86) across the ribbons.
Place a generous spoonful of gold printing ink onto the
screen, corresponding with the position of the ribbons.

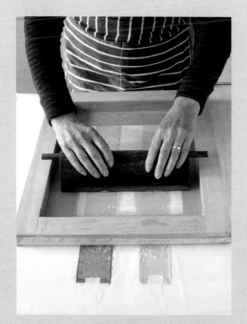

3

Make sure that there is enough ink to pull the full length of the screen. Squeegee one wet and one dry pull (see p.89).

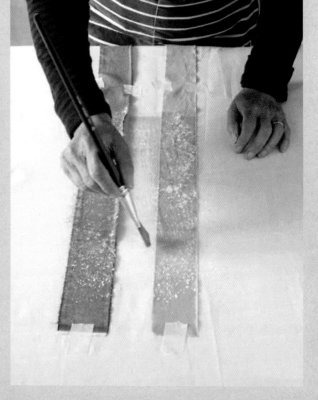

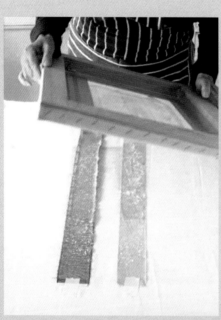

4

Lift the screen carefully. If you wish, you can print a second area further along the length of the ribbon. Do not place the wooden frame of the screen over the first printed area when it is still wet.

5

Allow the ink to dry. (Don't be tempted to use a hairdryer to speed up the process, as the loose powder will be blown onto the wet ink.) Gently brush away the talcum powder to reveal the delicate sprinkle pattern. To finish the rag ribbons, pull the loose threads from the sides and ends to create a fringed effect. Clean the screen and squeegee and allow to dry. Repeat the method using the satin ribbons and blue printing ink.

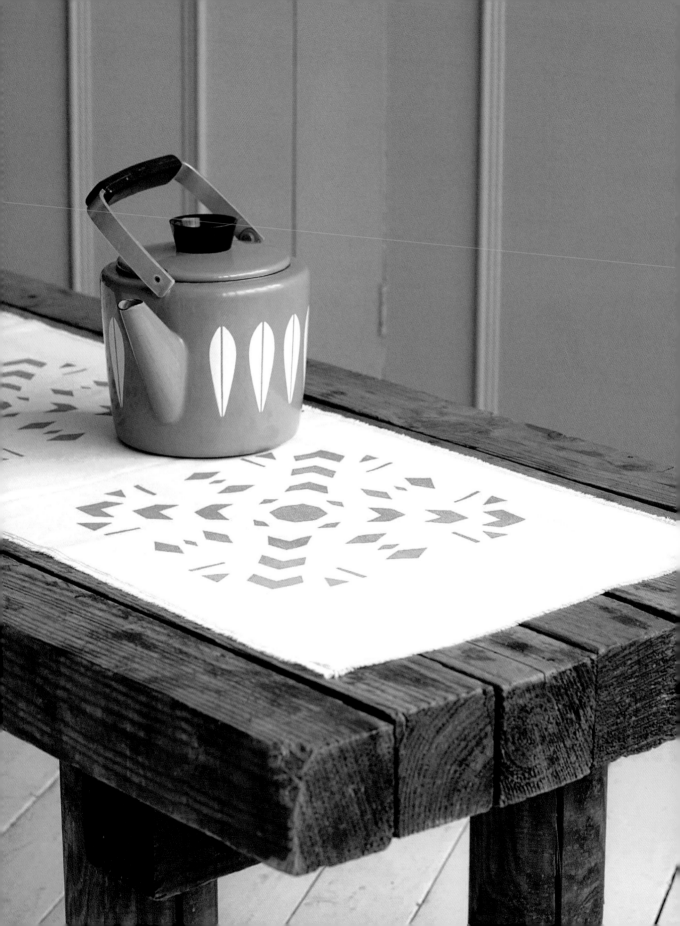

snowflake table runner

The method used for this vibrant design is sometimes called 'paper pick-up'. After the first pull of ink across the screen, the paper stencil sticks to the inky screen mesh. The stencil can be used to print several more images before it gets too soggy. This table runner could be designed to coordinate with the Autumn Leaves Napkins in Chapter 2 (see p.46).

screen blocked with hand-cut paper stencil

MATERIALS

Gum strip
Prepared open screen
Scissors
Newsprint or recycled paper
Linen fabric (approximately 35 x 125cm/
 13¾ x 49in) and orange thread;
 or your own table runner
Masking tape
Tailor's chalk or soft pencil
Orange printing ink
Tablespoon
Squeegee

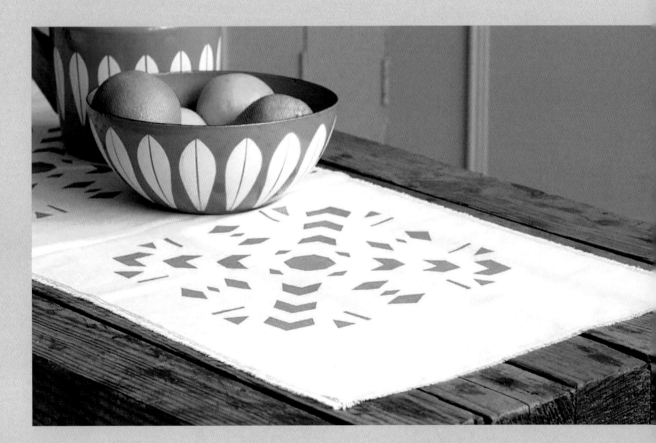

1

Using gum strip, frame off a 25cm (10in) square in the centre of the prepared screen (see p.86). Allow the gum strip to dry.

2

Cut a 25cm (10in) square of newsprint or cheap-quality recycled paper. This thin, absorbent paper will stick to the screen. Fold in half and then half again. Using scissors, snip out shapes and patterns from the four edges. Unfold the paper to reveal your paper snowflake.

3

This stencil repeats three times along the length of the runner. The border at each end measures approximately 12cm (4¾in) and the spaces between the pattern are approximately 10cm (4in). The stencil is printed 5cm (2in) in from the side edge.

4

Place your fabric onto the printing surface and fix with masking tape. It's a good idea at this point to mark guidelines for all three areas to be printed. Use tailor's chalk or a soft pencil. Place your stencil into position for the first print. Place your screen over the stencil so that the 25cm (10in) square framed printing area matches the four sides of the stencil.

5

Spoon five tablespoons of ink at one end of the screen and spread across the width of the screen. Squeegee two wet pulls and one dry pull (see p.89).

6

Carefully lift your screen. The paper stencil will now be stuck to the wet mesh. Place your screen into position for the second and then the third image. Check that you still have enough ink on your screen to print the whole image each time.

7

Allow the ink to dry before moving and fixing (see p.140). Clean the screen and squeegee.

8

To finish your own table runner, sew two parallel lines of straight machine stitch 1cm (½in) in from the edge around all four sides. Pull the threads from outside the stitch lines to create a frayed border.

I've chosen a very simple snowflake design – the sort you probably made in primary school.

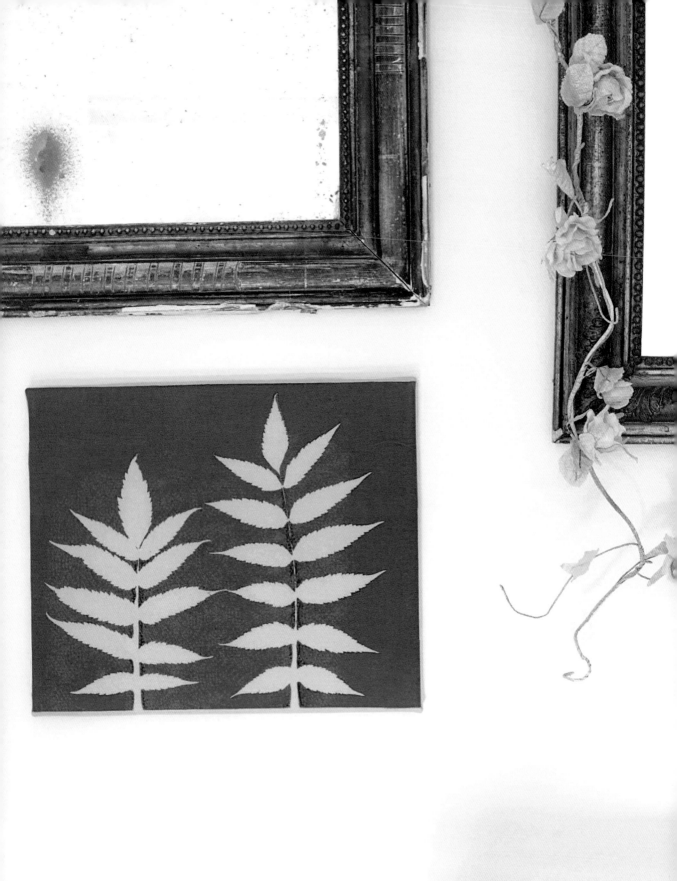

nature negative **wall art**

For this beautiful wall art, you don't need to 'press' your leaves, but it's a good idea to lay them separately between sheets of newspaper for twenty-four hours. This dries them a little and flattens them as well. I've printed onto green cotton fabric first, which was then stapled to a deep canvas. This enables you to change your picture with the seasons for an up-to-the-minute look.

single-colour print; screen blocked with natural form

MATERIALS

Deep artist's canvas
Cotton fabric
Gum strip
Prepared open screen
Masking tape
Leaves
Grey printing ink
Tablespoon
Squeegee
Staple gun and staples

1

Take the measurement of your artist's canvas and add 5cm (2in) to each side. Cut your fabric to this size. This will allow you enough fabric to fold behind the frame for stapling.

2

Using gum strip, frame a suitable area on your prepared screen (see p.86). (Mine measures 25 x 30cm/10 x 11¾in.) Allow the gum strip to dry.

3

Fix the fabric to the printing surface using masking tape.

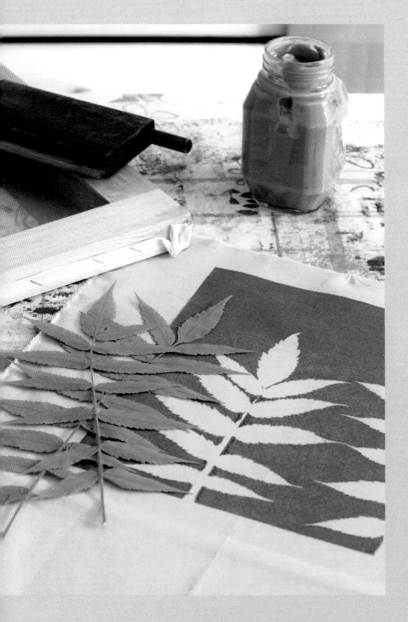

4

Place your leaves onto the fabric within the 25 x 30cm/10 x 11¾in rectangle (use guidelines if you wish).

5

Place your screen over the leaves, matching the framed area on the screen to the corresponding printing area on the fabric.

6

Spoon five tablespoons of printing ink onto one end of the screen and spread evenly along the width. Squeegee two wet pulls and one dry pull (see p.89).

7

Carefully remove the screen and the leaves. Allow the fabric to dry before moving and fixing (see p.140). Clean the screen and the squeegee.

8

Lay the printed fabric centrally over the artist's canvas. Along the top edge, fold the turnings to the back of the frame and staple in place. Repeat this on all four sides. Tuck and fold the corners and staple for a neat finish.

Collect leaves in the autumn and let nature do the design work for you.

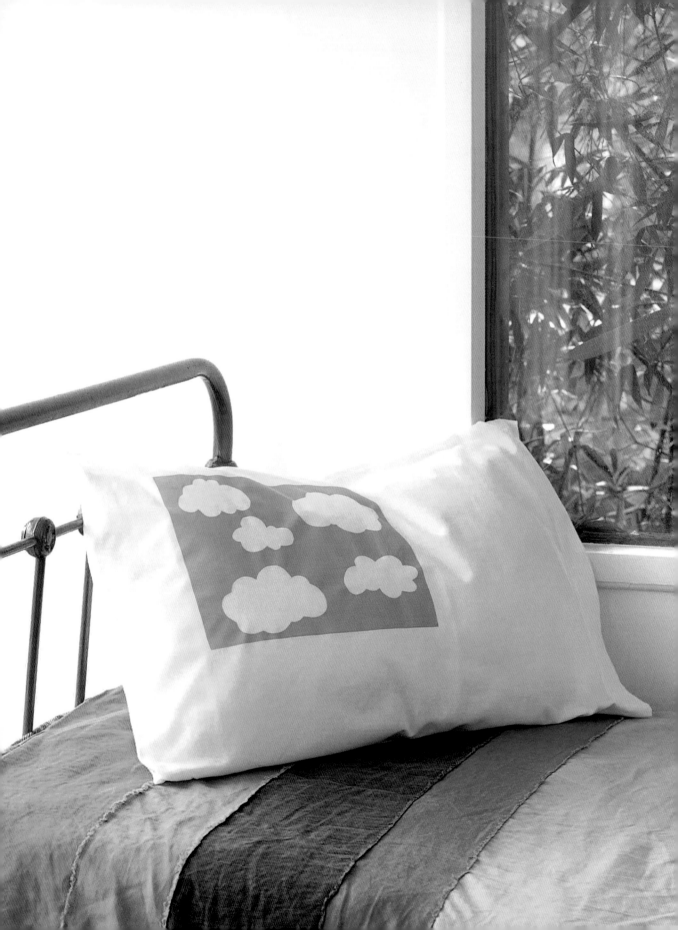

upcycle project blue-sky cloud pillowcase

Is this what is meant by 'blue-sky thinking'? You're guaranteed sweet dreams with your head in these clouds! This project is another 'pick-up' print, but in reverse – here, we keep the cut-out shapes and use them to create the image. You may want to print a matching design as a border on a sheet or a duvet cover.

screen blocked with hand-cut paper clouds

MATERIALS

Newsprint or similar
Craft knife
Cutting mat
Gum strip
Prepared open screen
Pillowcase
Masking tape
Tailor's chalk or soft pencil
Sky-blue printing ink
Tablespoon
Squeegee

1

Use the templates (see p.137) or draw and cut your own clouds from newsprint. This thin, absorbent paper will stick to the screen.

2

Using gum strip, frame an area approximately 23 x 29cm (9 x 11½in) in the middle of the prepared screen (see p.86). Allow the gum strip to dry.

3

Lay the pillowcase flat onto the printing surface. Place several sheets of newsprint inside the pillowcase to ensure that the ink does not spread through to the back. Fix the pillowcase into position using masking tape.

You could add extra interest to your sky with a hand-cut bird or sun.

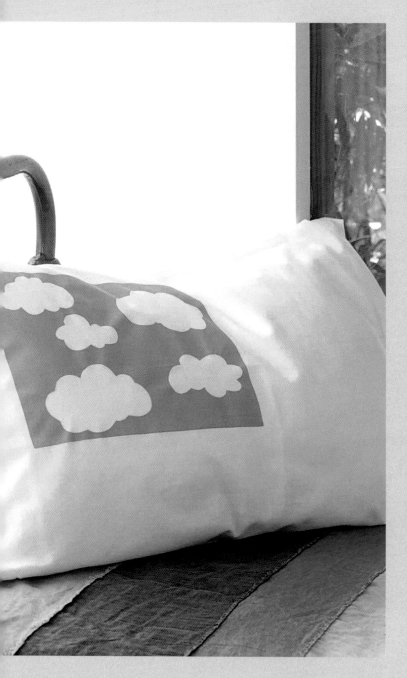

4

Using tailor's chalk, mark the position of the 23 x 29cm (9 x 11½in) rectangle onto the pillowcase. Don't print right up to the edge of the pillowcase – the thick seams and turnings create an uneven printing surface.

5

Place your paper clouds onto the pillowcase within the marked rectangular area. Lay your screen over the clouds, matching the framed area on the screen to the corresponding printing area on the pillowcase.

6

Spoon five tablespoons of printing ink onto one end of the screen and spread evenly along the width. The printed area is quite large on this design. Squeegee three wet pulls and one dry pull (see p.89).

7

Carefully remove the screen. The paper clouds will be stuck to the wet mesh. You could print a second pillowcase – it's a good idea to have one ready that has been pre-prepared and marked. Alternatively, you could print a matching border on a sheet or duvet cover.

8

Clean the screen and squeegee.

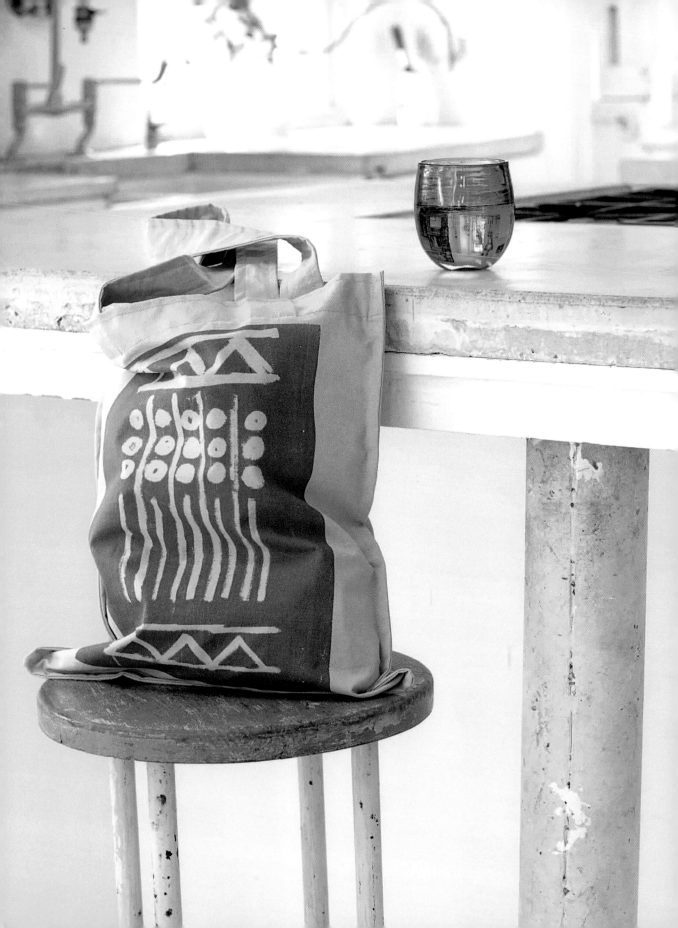

wax design totem bag

This design was inspired by African textiles and features a simple but strong, contemporary image. The character of this printed image is achieved by the uneven texture and irregular quality of the lines that result from using wax. Experiment to find the amount of wax and pressure needed to obtain the look you want.

screen blocked with hand-drawn wax design

MATERIALS

Paper
Cotton bag
Prepared open screen
Wax candle or fat wax crayon
Newsprint or similar
Masking tape
Grey printing ink
Tablespoon
Squeegee
Spare piece of fabric for trials
Kitchen paper

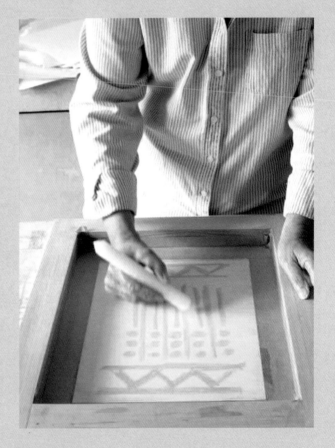

1

Use the template (see p.139) or draw your own design onto paper. Make sure that the size of the design fits your bag size, avoiding seams and hems. Place the prepared screen over the design, mesh-side down. Using a wax candle or fat wax crayon, trace the design onto the mesh. A lot of wax needs to be deposited in order for this method to be successful. Hold your screen up to the light to check that the wax is blocking the mesh.

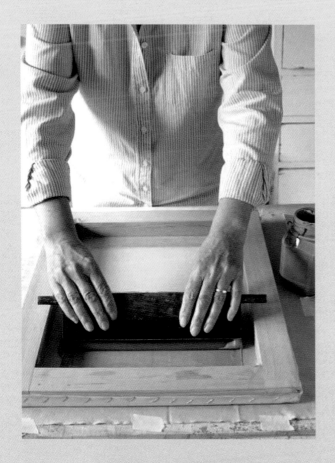

2

Place several sheets of newsprint or similar into the bag. This ensures that the ink does not spread from the front to the back of the bag. Lay the bag onto the printing surface and fix in position with masking tape. Place five tablespoons of printing ink onto the screen at one end and spread the ink to fill the width of the screen. Squeegee two wet pulls and one dry pull (see p.89).

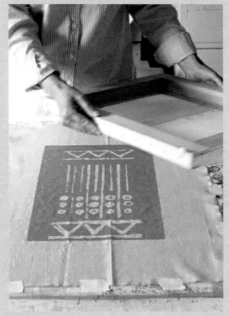

3

Carefully lift the screen and allow the ink to dry before moving and fixing (see p.140). Clean the screen and squeegee. To remove any remaining wax, pour hot water over the mesh or iron out onto kitchen paper. Use paper on both sides of the mesh to protect the mesh and the iron.

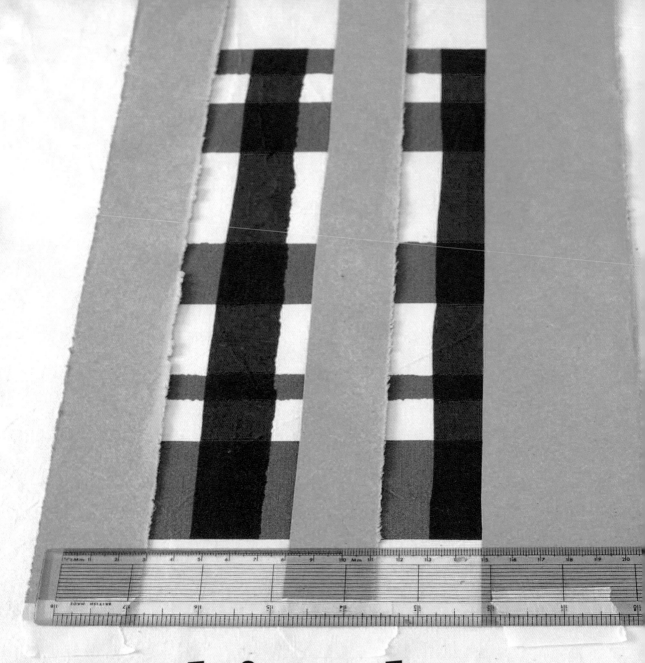

combined & advanced techniques

Before you begin any of the
projects in this chapter, you
should already be confident
using the techniques detailed
earlier in the book. Of course,
most of these printing methods
are interchangeable – you
could print cloud wall art,
for instance, or a leafy
pillowcase. The techniques
can also be combined, and
the possibilities are infinite.
I hope that this chapter will
encourage you to carry on
beyond the projects, and
inspire you to create your
own unique designs.

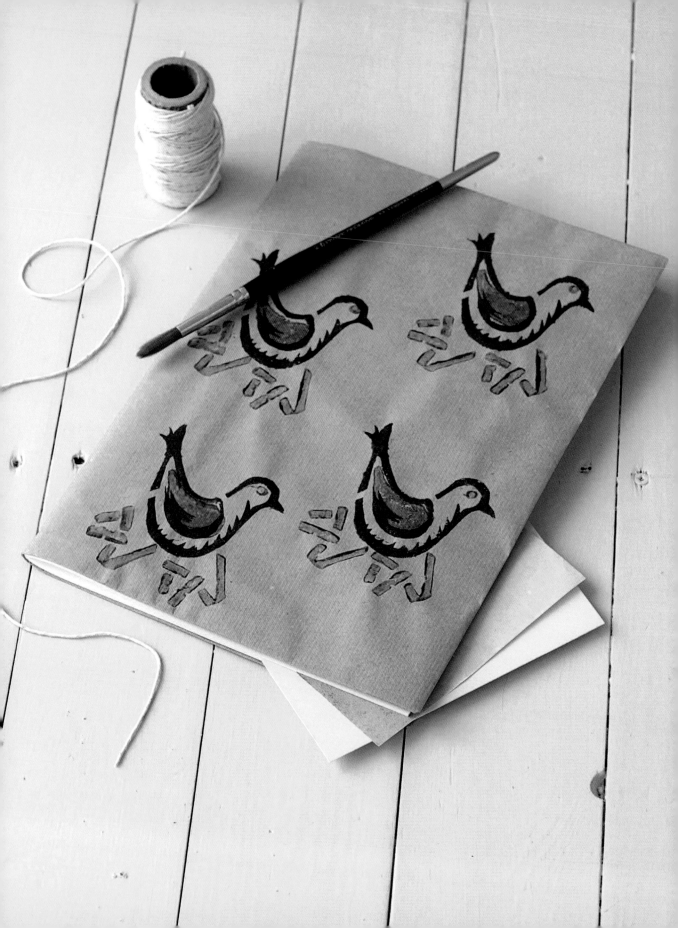

brown paper bird book cover

Personalize your special books with this 'bird on a nest' design. The book cover, made from brown wrapping paper, combines several types of mark-makers – including potato printing and sponging through a stencil – and may inspire you to think of other items to use for printing.

combines potato printing,
sponging through a stencil and
printing with a pencil

MATERIALS

Tape measure
Scissors
Brown wrapping paper
Card
Craft knife
Cutting mat and board
Pencil
Masking tape
Brown, black and red printing inks
Tablespoon
Metal or plastic trays
Pieces of sponge
Kitchen paper
Two potatoes
Felt
Clear sticky tape or glue

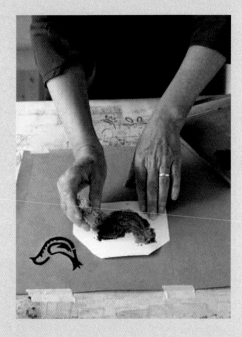

1

Measure the front and back of your
chosen book and add 3cm (1¼in) on
all four sides for turnings. My book
measures 30 x 44cm (11¾ x 17⅓in) if
the front and back are combined. My
piece of paper is 36 x 50cm (14¼ x
19½in). Cut your piece of brown paper.
Using the template (see p.137), craft
knife and cutting mat, cut the bird
stencil. To ensure the birds are well
placed, pencil a line from top to bottom
through the centre of your paper.
Also mark a 3cm (1¼in) border around
all four sides. With the matt side
uppermost, fix your paper to the
printing surface using masking tape.
Prepare your tray, black ink and sponge.
Stencil the bird images onto the front
cover. If your stencil is still in good
condition, press it between two sheets
of kitchen paper to clean and then
use the reverse side to print the back
cover. If the stencil is too soggy,
cut another one for the back. Let
the ink dry before printing the
next colour.

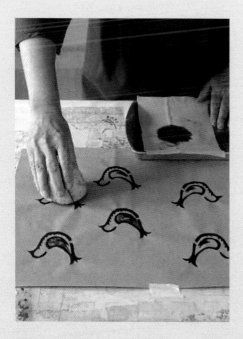

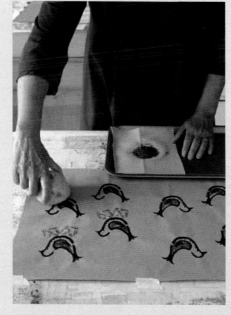

2

The red wings are printed with a potato. You need to cut one for the front cover and another, in reverse, for the back cover, using a cutting board and a craft knife (see p.14). Prepare your tray, red ink and felt. Using the cut potato, print the front wings. Using the reverse-cut potato shape, print the back wings.

3

The nest is also a potato print – the same image is printed twice. Referring to the nest design on page 112, cut out thin rectangular shapes in the potato (see p.14). Next prepare your tray, brown ink and felt. Using the cut potato, print the nest image twice beneath each bird.

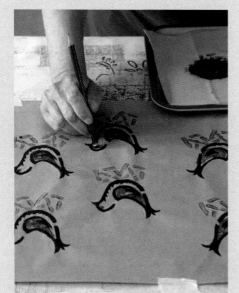

4

Dab the unsharpened end of a pencil onto the felt pad and print the bird's eye using the brown ink.

5

Cover your book. Fold the brown paper along the central pencil line top to bottom. Open out again. Lay your book centrally onto the unprinted side of your paper. Fold over the 3cm (1¼in) borders along the pencil lines on the side edges of the front and back. In order to fold over the top and bottom turnings, cut the brown paper on the centre line, 3cm (1¼in) at the top and 3cm (1¼in) at the bottom. Fold over the top and bottom edges. Use clear sticky tape or glue to fix the four corners, trimming first if necessary.

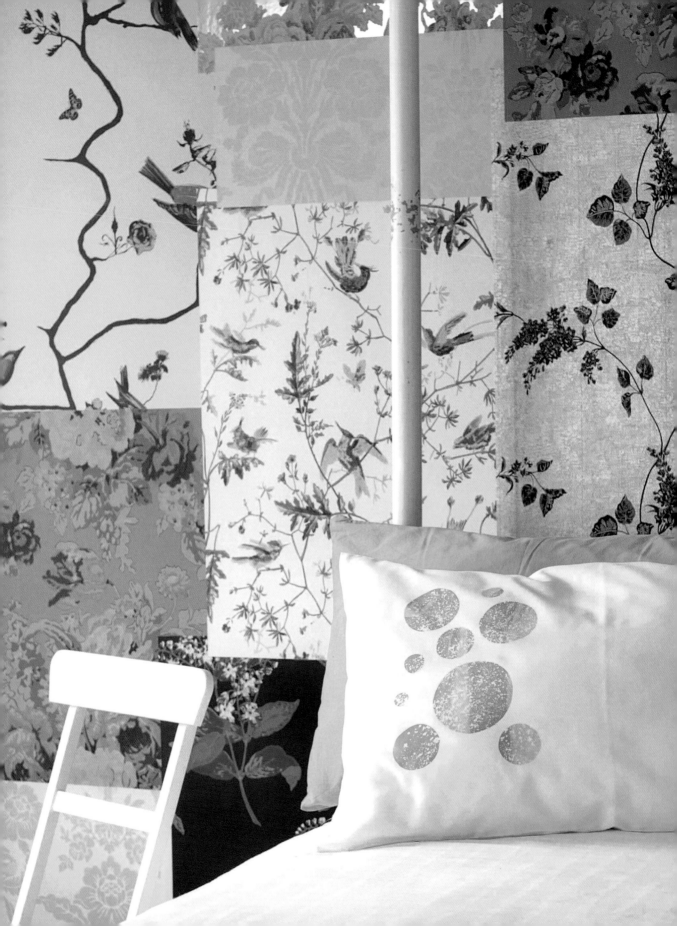

upcycle project pink and
blue
bubbles
pillowcase

The marbling on this design creates an attractive effect, and is a technique that's worth practising. Stirring the colours together a little helps them to blend when they are printed. You can add any number of colours at any point during printing to create a more complex marbled pattern.

combines an open-screen 'paper pick-up' print, a talcum powder block and mixed-ink marbling

MATERIALS

Gum strip
Prepared open screen
Newsprint or similar
Soft pencil
Set square
Ruler
Circular objects to draw around
Craft knife
Cutting mat
Pillowcase
Masking tape
Tailor's chalk or soft pencil
Talcum powder
Pink and blue printing inks
Tablespoon
Squeegee
Soft brush

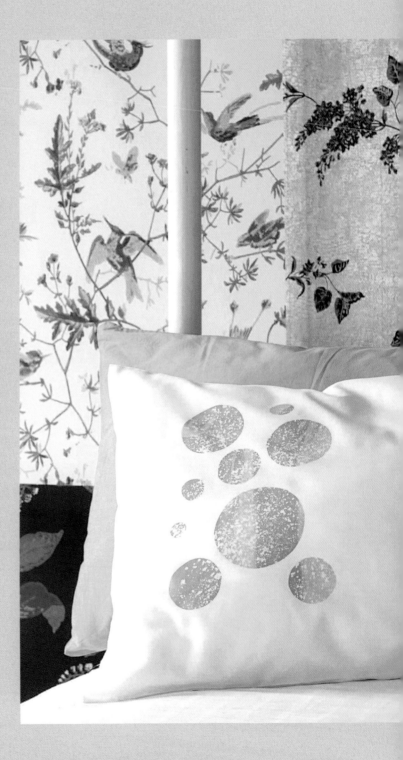

By changing the colours that you use, you can turn these bubbles into planets.

1
Using gum strip, create a frame in the centre of the prepared screen (see p.86) that leaves an open mesh rectangle measuring 35 x 25cm (13¾ x 10in). Allow the gum strip to dry.

2
On a large sheet of newsprint or similar, draw a rectangle measuring 35 x 25cm (13¾ x 10in). You will need several centimetres of paper outside this rectangle for handling.

3
Within the rectangle, draw different-sized circles. I drew around a cup, a saucer, a bowl and a small bottle. Using a craft knife and cutting mat, cut out the circles and discard.

4
Place several pieces of newsprint between the front and back of the pillowcase to prevent the ink from spreading through. Tape the pillowcase to the printing surface using masking tape.

5
Use tailor's chalk to mark the rectangle that is to be printed on your pillowcase. Sprinkle the area generously with talcum powder.

6
Lay the circle stencil over the pillowcase, matching the guidelines.

7
Then lay the prepared screen over, matching the guidelines.

8
Dot tablespoons of the pink and blue inks alternately along one end of the screen. Stir them together a little so that they blend.

9
Squeegee two wet pulls (see p.89). This will give you a random marbling effect – each print will be different. (More than two pulls tends to make the colours mix too much.)

10
Allow the ink to dry completely before lightly blowing or brushing away the talcum powder. Fix the colours (see p.140). Wash the screen and squeegee.

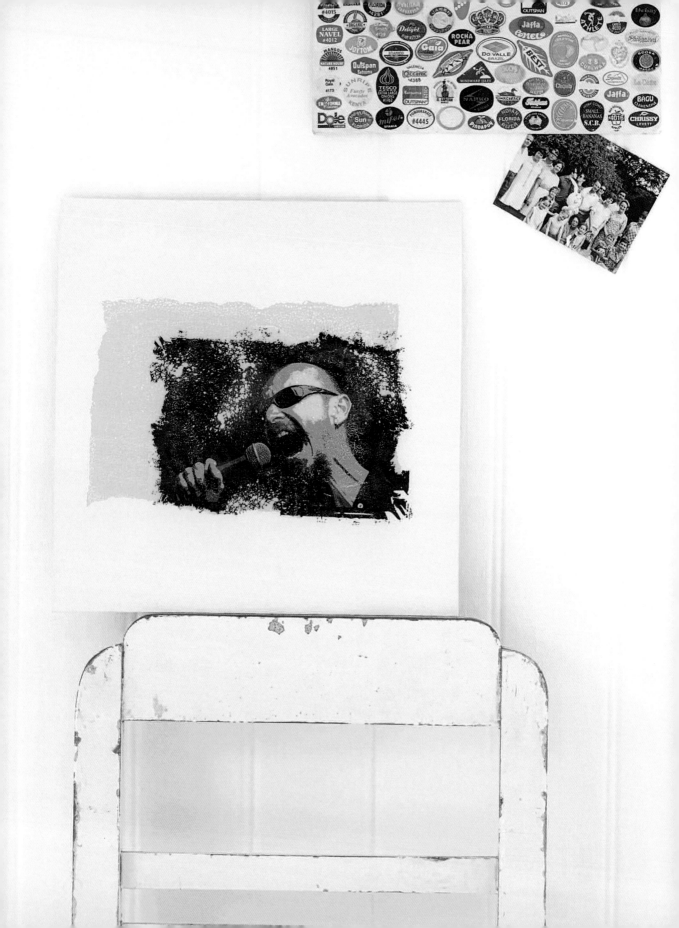

two-colour
portrait
of a singer

Two versatile techniques – open screen and transfer printing – combine here to make ART! The yellow rectangle is printed directly onto an artist's canvas. The black image of the singer, enhanced by the 'posterize' effect in Photoshop, is then applied using a transfer method.

combines an open-screen print
and a transfer print applied to
an artist's canvas

MATERIALS

Computer and software
Image scanner
Printer
Image transfer paper
Newsprint or similar
Prepared open screen
Masking tape
Flat artist's canvas
Yellow printing ink
Tablespoon
Squeegee
Iron

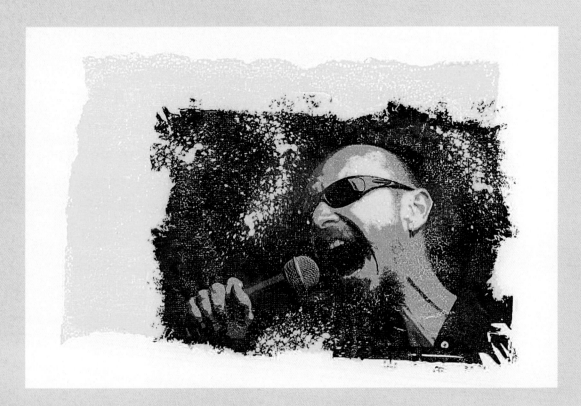

1

The 'singer' image was created using the image manipulation software Photoshop, on an Apple Mac computer. Scan your chosen image or use an image from a stock photo website. Convert it to black and white, and use a 'posterize' filter for dramatic effect. To create the destroyed edge, lay the image over a 'grunge' background from a stock photo website.

2

Print the black-and-white image onto image transfer paper.

3

To create a 'frame', tear four wide strips of newsprint or similar. Fix to a prepared screen (see p.86) using masking tape. The torn paper gives the printed rectangle an irregular edge that is more interesting. Make sure that the size of your framed area corresponds to the size of your artist's canvas.

4

Place the artist's canvas onto your printing surface. Lay the screen over, placing the framed area a little off-centre. Using yellow ink, print with only one pull of the squeegee (see p.89). This gives an intentionally poor-quality, uneven print. Allow the ink to dry. Clean the screen and squeegee.

5

Lay the transfer image over the yellow rectangle – again, a little off-centre. Follow the manufacturer's instructions to transfer the image.

6

Hang the picture on the wall!

Experiment in Photoshop – there are endless ways to manipulate your images before printing.

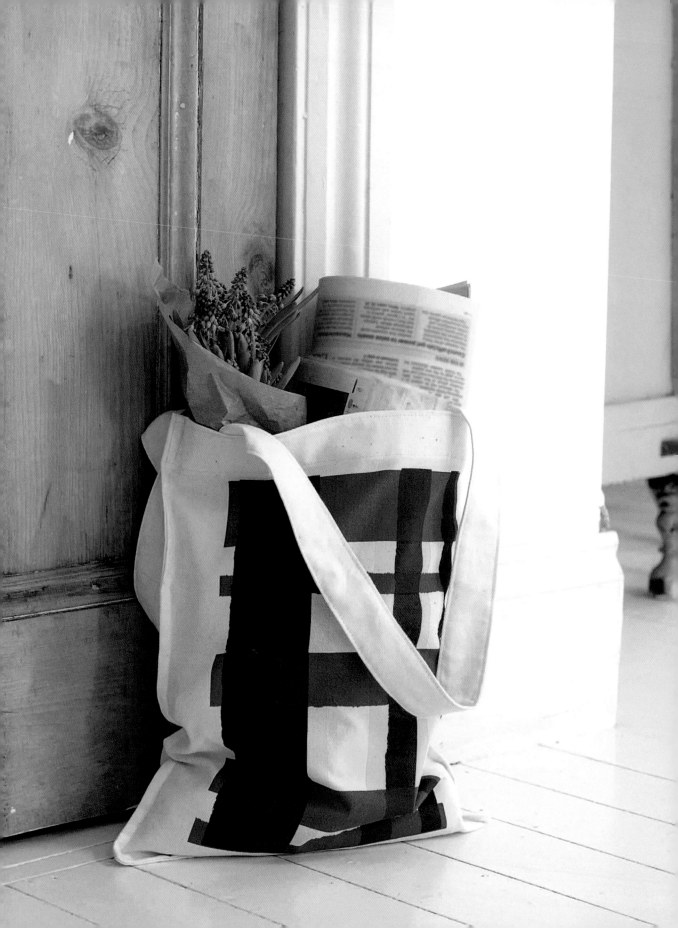

vibrant tartan tote

Taking the 'paper pick-up' idea a little further, you can create a very convincing tartan. The colour variations are limitless, but it's worth giving this careful thought. Overprinting the colours will produce a whole range of new colours where they overlap. The red, blue and yellow that I used made maroon, orange, brown and green too. Enjoy experimenting!

'paper pick-up' strips produce a tartan design

MATERIALS

Prepared open screen
Cotton bag – washed to remove finish
Sugar paper
Pencil
Scissors
Ruler
Newsprint or similar
Masking tape
Red, blue and yellow printing inks
Tablespoon
Squeegee

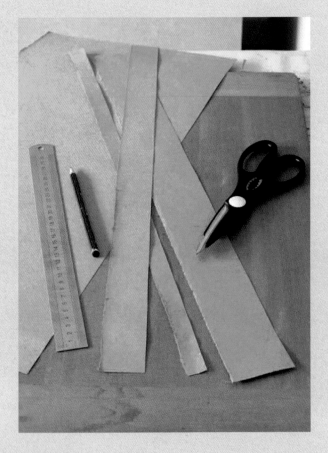

1

When you prepare your screen with gum strip (see p.86) create a 'framed' printing area that suits the size of your bag. My bag measures 39 x 30cm (15½ x 11¾in). The printed area measures 30 x 20cm (11¾ x 7¾in); this size ensures that the seams or hems are not printed over. For the first print, I prepared four paper strips cut from sugar paper. They are all 50cm (19½in) long; two are 2.5cm (1in) wide, one is 4cm (1½in) wide, and one is 6cm (2¼in) wide. I cut one side with scissors and tore the other side with a ruler to add more interest to the printed image.

This method is deliberately prescriptive to ensure that beginners can achieve a successful tartan.

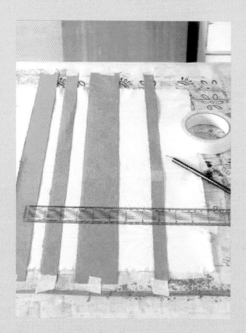

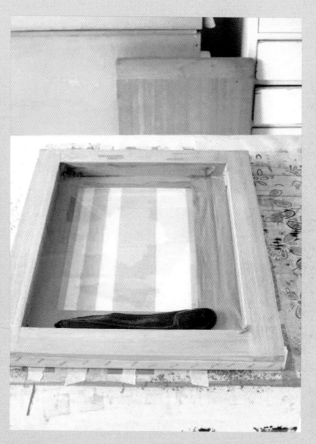

2

Place several sheets of newsprint or similar inside the bag – this prevents ink spreading from the front to the back. Lay the bag onto the printing surface and fix in place using masking tape. Lay the paper strips across the bag, top to bottom. Hold in place with masking tape. Remember, the paper strips will block the ink and the clear areas will be printed red.

3

Place the prepared screen over the paper strips. Using the red printing ink, squeegee two wet pulls and one dry pull (see p.89). Remove the screen and carefully remove the paper strips. Allow the ink to dry. Clean the screen and squeegee and allow to dry. You can use a hairdryer to speed up this process.

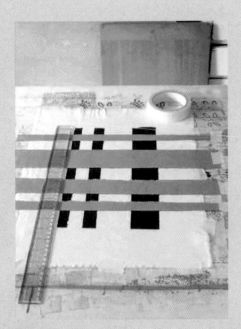

Varying the size of your strips and gaps creates interesting and unexpected overlaps of colour.

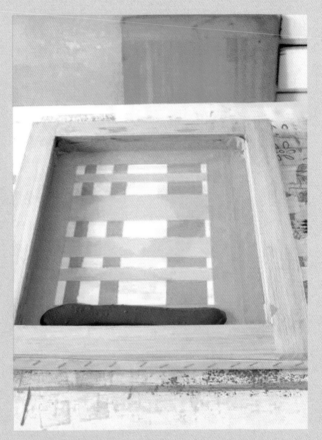

4

Cut and tear four more paper strips. They are 25cm (10in) long; two are 2.5cm (1in) wide, one is 4cm (1½in) wide, and one is 6cm (2¼in) wide. Lay these across the bag at right-angles to the printed red stripes. Hold in place with masking tape.

5

Place the screen over. Using blue ink, squeegee two wet pulls and one dry pull. Remove the screen and carefully remove the paper strips. Allow the fabric to dry. Wash the screen and squeegee and allow to dry.

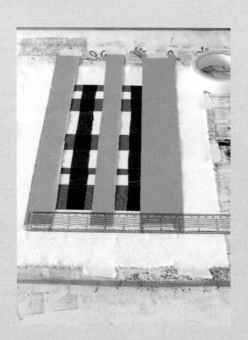

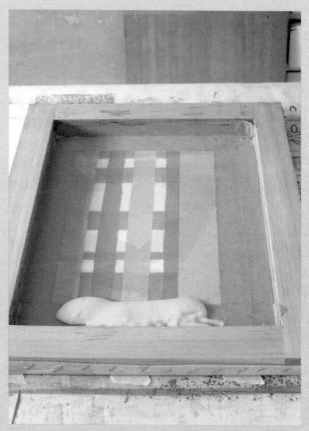

6

Cut and tear three more paper strips. They are 50cm (19½in) long and 3cm (1¼in), 4cm (1½in) and 6cm (2¼in) wide, respectively. Your third colour will have a big effect on the colours already printed. Think carefully about where you want the background colour to show and place the paper strips accordingly. Hold in place using masking tape.

7

Lay the screen over and, using yellow ink, squeegee two wet pulls and one dry pull. Remove the screen and the paper strips. Allow the fabric to dry before removing and fixing (see p.140). Clean the screen and squeegee.

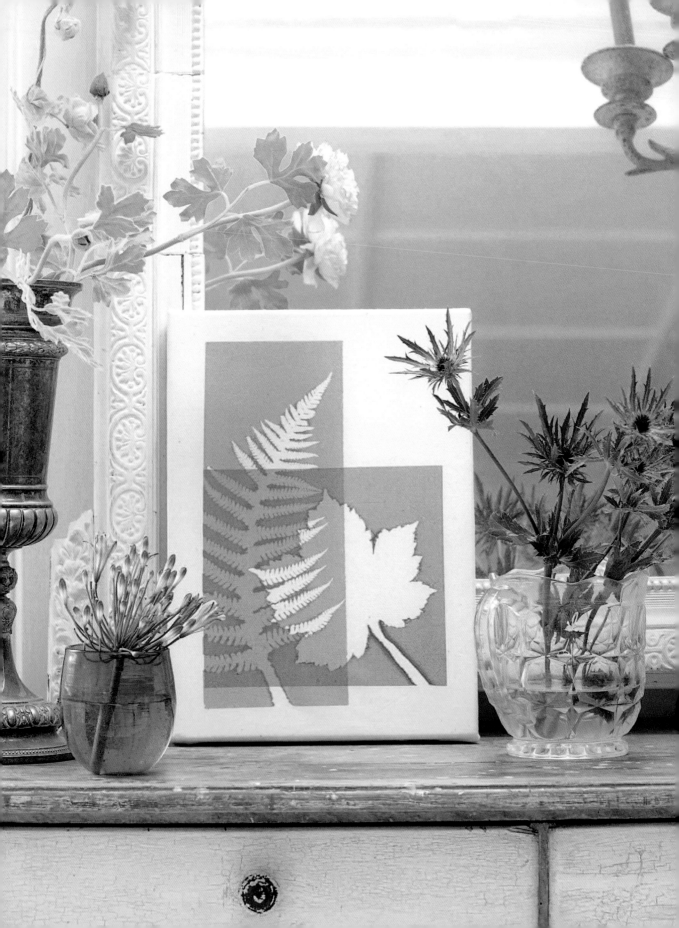

two-leaf negative wall art

By overlapping two colours and two leaf images you can achieve a stunning composition. If you decide to print directly, use a flat canvas. For this project, I printed onto natural calico because I love its creamy colour for the background. The printed fabric can then be stretched over and stapled onto a deep artist's canvas.

two-colour print; combined negative images in two overlapping colours

MATERIALS

Deep artist's canvas
Leaves
Ruler
Scissors
Fabric
Tailor's chalk or soft pencil
Prepared open screen
Newsprint or similar
Gum strip
Masking tape
Olive and grey printing inks
Tablespoon
Squeegee
Staple gun and staples

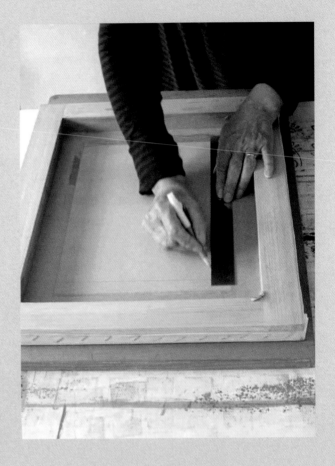

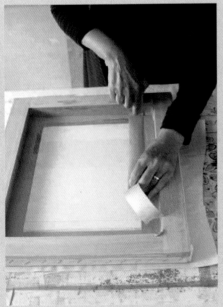

1

Decide on your canvas size first and then choose leaves that fit attractively into that space. Measure the canvas and add 3cm (1¼in) to all four sides. Cut your piece of fabric to this size. Use tailor's chalk to mark out your desired printing area on the mesh of the prepared screen (see p.86). My fabric is 50 x 40cm (19½ x 15¾in) and my printing area is 30 x 20cm (11¾ x 7¾in).

2

Place newsprint or similar onto the printing surface and use wet gum strip to create the frame for your printing area. Allow the gum strip to dry.

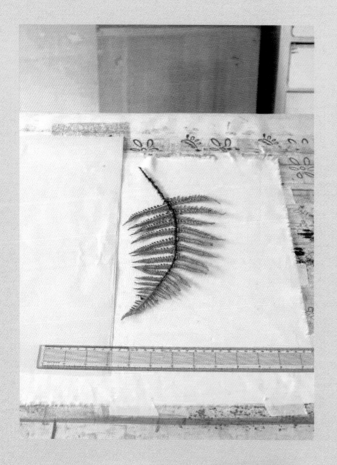

3

Fix your fabric to the printing surface using masking tape. With tailor's chalk, mark the four corners of the 30 x 20cm (11¾ x 7¾in) rectangle as a guide. Place a leaf onto the left-hand side of the printing area. Place a rectangle of newsprint over the right-hand side of the printing area – place so that it prevents ink from printing on an 8cm (3¼in) strip down the right-hand side of the printing area. Ensure that the newsprint extends beyond the gum strip frame at the top, bottom and right-hand side.

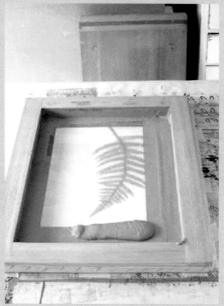

4

Place the screen over, matching the guidelines. Place three tablespoons of olive printing ink onto the screen, corresponding to the area to be printed.

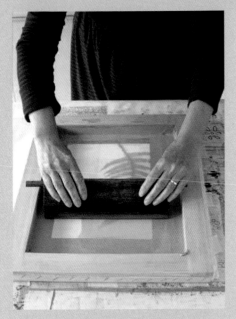

5

Squeegee two wet pulls and one dry pull
(see p.89). Lift the screen and remove the
leaf carefully. Allow the ink to dry. Clean the
screen and squeegee and allow to dry.

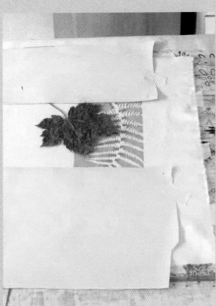

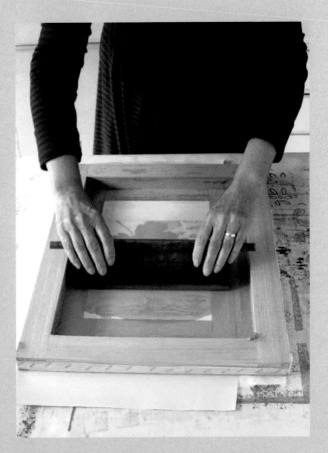

6

Place the second leaf in position,
overlapping the first printed leaf. Next,
using rectangles of newsprint, block
two areas – the first covering 9cm
(3½in) from the top edge of your design
area, and the second covering 2cm
(¾in) up from the bottom edge of
your design area.

7

Place the screen over, matching the guidelines. Place
three tablespoons of grey printing ink onto the screen.
Squeegee two wet pulls and one dry pull.

8

Lift the screen and carefully remove the leaf and the inky newsprint. Allow the ink to dry before moving and fixing (see p.140). Clean the screen and squeegee.

9

Place the artist's canvas centrally onto the wrong side of the printed fabric. Fold back the 3cm (1¼in) border and staple the fabric to the frame on one side of the canvas. Check that the fabric is straight. Staple the other three sides. Fold over and staple the corners.

templates

The templates provided here have been reduced in size to fit on the page. You will need to photocopy the templates at 200% to achieve the dimensions given on each template.

kind of blue cushion (p.50)

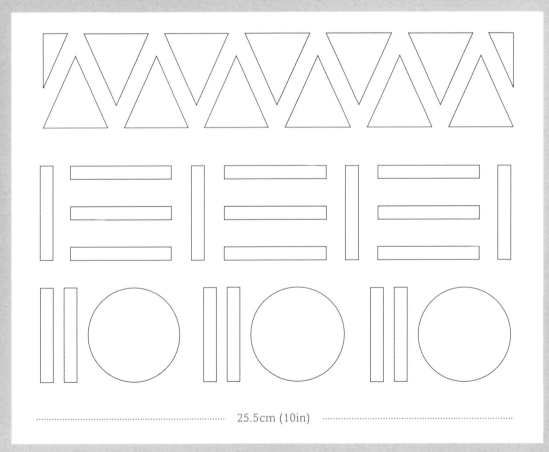

25.5cm (10in)

brown paper bird book cover (p.112)

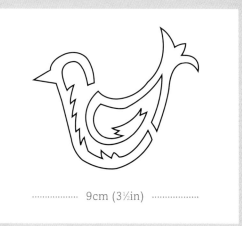

·············· 9cm (3½in) ··············

blue-sky cloud pillowcase (p.102)

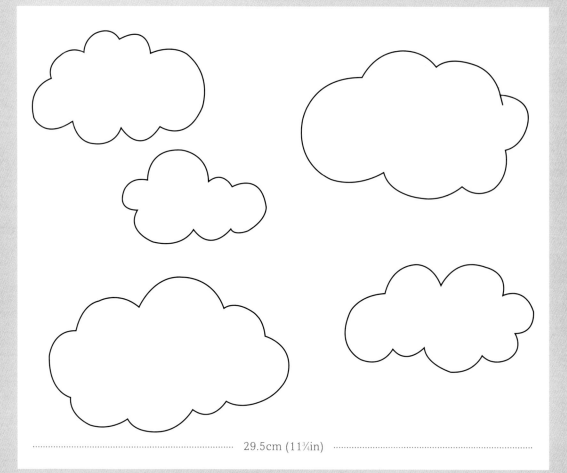

················ 29.5cm (11¾in) ················

blue and orange wall stencil (p.58)

.. 28cm (11in) ..

daisy border
tea towel
(p.42)

.............. 8.6cm (3⅓in)

autumn leaves napkins (p.46)

25.5cm (10in)

wax design totem bag (p.106)

30.3cm (12in)

glossary

finish

Residue left in the fabric from the manufacturing process that resists some inks. Wash most new fabrics before printing.

fixing

Most printing inks will wash out unless they are made permanent by fixing. Follow the manufacturer's instructions for individual printing inks. A common method is ironing with a hot iron. Check that your chosen fabric can be ironed at the required heat before printing.

gum strip

Brown paper strip with gum on one side. It sticks when wet. To remove, soak the gum strip thoroughly and it will peel off.

masking tape

An adhesive tape for holding fabric in place.

mesh

Fabric that is stretched taut and stapled to wooden frames or glued onto metal frames. Historically, silk was used but now most printers use man-made fibre. It's possible to buy frames with the mesh already fixed, or you can make your own.

mulberry paper

Textured tissue paper.

newsprint

Unprinted newspaper. Cheap and absorbent, it has many uses. When preparing a screen with gum strip, newsprint placed beneath the screen will soak up moisture, and when placed between the front and back of a garment it prevents ink from spreading from the printed side to the unprinted side. Because it is thin and absorbent, it is also ideal for 'paper pick-ups'. It is easily torn for framing and cheap enough to be discarded after use. Available from art and craft shops or from online suppliers. Local printers may also sell it to you direct – it's worth asking. If newsprint is not available, poor-quality recycled paper or kitchen paper is good. Avoid actual newspaper, as ink from this can transfer to your fabric.

registration

The correct alignment of two or more overlapping printed images.

running stitch

The most basic stitch, where the needle is passed in and out of the fabric at regular intervals along the stitch line. Worked by hand and then pulled out after use.

screen

A strong frame made from wood or metal. These can be purchased in a variety of sizes from art and craft shops or printmaking suppliers. You can make your own very cheaply or even adapt an old window frame.

squeegee

A straight piece of firm rubber held in a wooden handle. Used to push ink through the mesh when screenprinting.

tailor's chalk

Used to make temporary markings on cloth. Comes in block or pencil form.

resources

I have not included a big list of suppliers here. The materials and equipment for the projects in this book can almost certainly be obtained at or through your local art and craft shop. Stationers and office suppliers, and even hardware stores, are also worth a visit. If you have problems locating what you need locally then the internet is the next best thing for your own research. The addresses and websites included here will be of most use to those of you who wish to take your craft further.

Daler-Rowney Limited
Peacock Lane
Bracknell
RG12 8SS
www.daler-rowney.com

Specialist Crafts Limited
PO Box 247
Leicester
LE1 9QS
www.homecrafts.co.uk

George Weil & Sons Limited
Old Portsmouth Road
Peasmarsh
Guildford
Surrey
GU3 1LZ
www.georgeweil.co.uk

Candlemakers Supplies
Behind 102–104 Shepherds Bush Road
London
W6 7PD
www.candlemakerssupplies.co.uk

Sericol Limited
Pysons Road
Broadstairs
Kent
CT10 2LE
www.fujifilmsericol.com

index

acknowledgements

With thanks to my daughter Holly for her beautiful photography (www.hollyjolliffe.co.uk), and to my husband Steve for his constant support.

Thanks also to Miriam Hyslop, Nina Sharman and Julia Halford at Pavilion for their friendly and professional help throughout.

about the author

Joy Jolliffe's fascination with screenprinting began at Art College while studying Fashion Design and Illustration. Joy later worked at her local high school developing creative textiles with the students. This involved surface decoration on fabrics including screenprinting, batik and direct painting. For the past nine years, Joy has run a successful online shop Random Retail (www.randomretail.co.uk) where she sells bespoke hand-printed products and writes a blog, *Sewing Notions*.

Find Joy on Twitter @RandomRetail2

PAVILION

Whatever the craft, we have the book for you – just head straight to Pavilion's crafty headquarters.

Pavilioncraft.co.uk is the one-stop destination for all our fabulous craft books. Sign up for our regular newsletters and follow us on social media to receive updates on new books, competitions and interviews with our bestselling authors.

We look forward to meeting you!

www.pavilioncraft.co.uk